縱觀現今林林總總的英語課外讀物,鮮有以寓學習於遊戲,讓學生在無壓力的情況下,認識及學習運用詞彙的。本書的50個填字遊戲均是根據本地學生普遍的學習程度,循序漸進地編寫。在「實用小錦囊」中,筆者更提供中英對照的例句及文法知識,務求方便學生自學及協助教師教學。

除了提供詞彙和文法知識,各篇分別設有「小笑話」、「小金句」及「你知道嗎」項目:一方面增加本書的趣味性,另一方面提供另類的閱讀種類(text type),讀者可以藉着本書,「一站式」地吸收這些分佈在不同學術領域的東西,並接受德智的啟導,而不是單單一個「人肉英語學習機器」。

筆者在此謹感謝匯識教育邀請我參與這一有趣的工作。 筆者才疏學淺,錯漏難免,希望各界不吝指正。最後,如 果本書能夠讓學生喜歡英語,日後自發地進行課外閱讀, 透過英語,接觸及領會西方文化的精神,那便是筆者最大 的心願了。

- ★ 透過生動的填字遊戲,認識及學習超過1000個英文生字。
- ★ 分「熱身篇」、「過渡篇」及「挑戰篇」,其中「熱身篇」 及「過渡篇」更設有「準備升級」題目,由淺入深,讓大家 循序漸進地學習不同的英語詞彙,及各詞彙的不同運用方法。
- ★ 每個考驗均有「實用小錦囊」,提供與所填生字相關的文法 知識及中英對照的例句,加深對各詞彙的認識及對文法的了 解。
- ★ 於錦囊內設有不同的有趣項目,認**識更多知識及西方文化**: 「**小笑話**」:

以惹笑的形式學習更多詞彙,從中認識西方文化。

小金句:

以精警的語句,啟發道德思維。

「你知道嗎」:

包含科學、歷史文化及英文用詞等知識,擴闊學習領域。

40

44

56

熱身篇

考驗1 ……

考驗9

考驗10

考驗2	 12
考驗3	16
考驗4	 20
考驗5	 24
考驗6	 28
考驗7	 32
考驗8	 36

熱身篇:準備升級

考驗11	7,7,7,7,7,7,7	48
考驗12		52

	ا موار	00
	考驗14	 60
-		

孝驗13 ...

考驗15	 	64

過渡篇

考驗1		70
考驗2		74
考驗3		78
─ 考驗4		82
考驗5		86
□ 考驗6		90
考驗7		94
考驗8	•••••	98
考驗9		102
考驗1	0	106

過渡篇:準備升級

考驗11	110
考驗12	114
考驗13	118
老驗14	122

126

考驗15

	考驗113	2	考驗11	 172
	考驗213	6	考驗12	 · 176
S	考驗314	0	考驗13	 180
	考驗414	4	考驗14	 184
	考驗514	8	考驗15	 188
	考驗615	2	考驗16	 192
	考驗715	6	考驗17	 196
	考驗816	0	考驗18	 200
	考驗916	4	考驗19	 204
200	考驗1016	8	考驗20	 208
			# 21	040

- - - -

難易度 ★ ② ② ② ②

▶横

1.	彩虹	的	一 種	重顏	色
----	----	---	------------	----	---

3.	童話故事常見的開場白	:	
	A long, long time		(很久很久以前)

- 6. He doesn't like it, _____ do l. (他不喜歡它,我也不。)
- 7. 「蘋果批」、「南瓜批」之類的「批」(餡餅)
- 8. 看見
- 9. 它的;牠的
- 10. 一截鋸或砍了下來的樹幹
- 11. do 的過去式
- 12. he fat?

- 1. 回答的過去式
- 2. 穿上衣服
- 3. 天使
- 4. _____ home (回家)
- 5. 橙的眾數

1	2	3	4	5
		6		
7				
	8			
9		10		
11			12	

横6

nor可以用來表示「也不」。例如:

- ★ My parents don't like it, nor do I. (我父母不喜歡它,我也不。)
- ★ They can't do it, nor can I. (他們做不到,我也不。)

橫12

英語中的am, are, is, was, were的原形是be,它們常用來連繫句子中的主語、形容詞(adjective)或名詞(noun),例如:

★ He is <u>clever</u>. (他是聰明的。)

★ I am a tall person.

(我是一個長得高的人。)

如果問的對象是對方或眾數,便要説成 'Are you / they hungry?' (你/他們餓嗎?)

注意:hungry 和fat都是形容詞 (adjective),是用來説出人 和事物的特點。

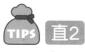

穿上衣服是這樣説的:

I am dressed in blue.(我穿上一身藍色衣服。) dress後面一定要加ed,前面一定要有am / are / is / was / were,這些字來表示時態及人數。

答案

而是sleep like a log(睡得像木頭一樣)。

- 1. 不開心
- 5. 運用;利用
- 7. 生病

- 8. _____ plane (飛機)
- 10. 不多; 很少
- 11. 'Is this _____ pen?' 'Yes, it is my pen.'

- 1. 通常
- 2. 鼻子
- 3. I _____ a hard-working student.
- 4. 黃色
- 6. 犯錯
- 9. 如果

1	2		3		1
1	2		3		4
5		6		7	
9		O		,	
8				A TOTAL STREET	
				9	
				10	
11					

橫1

很多形容詞加了un在開頭便會變成相反的意思,例如:

- ★ usual→unusual (平常 →不平常)
- ★ fit→unfit (合適 →不合適)
- ★ fair→unfair (公平 →不公平)

橫8

與空氣和飛行器有關的英文字通常都以aero開頭,例如aeronautics(航空學;航空術)和aerobatics(特技飛行)等。

橫10

Few是應用於可以數到的人或事物上,例如我們不可以說few water (很少水),而應該說a little water。

直1

我們可以用usually來説我們的習慣,例如:

★ I usually go swimming on Saturdays. (我通常在星期六去游泳。)

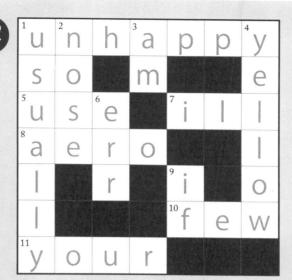

- 1. _____ television (看電視)
- Mother loves me.I like to talk to ______.
- 6. 臉上的一個器官
- 8. 變成
- 9. 煮東西
- 11. I go _____ the market by bus.
- 12. Mr. Chan is our English teacher. He gave some English story books to ______.
- 13. 濕的

- 1. 網
- 2. '_____you afraid?' 'Yes, I am.'
- 3. 時鐘的眾數
- 4. Tom is a naughty boy. I don't like to play with
- 7. 鉛筆
- 10. 出外。例句:Let's go _____ for a walk.

	1	2		3	4	
5				6		7
	8					
	9		10			
11			12			
	13					

橫1

看電影也可以用watch,如watch a movie / film。

横5 横12

him、her和us都表示它們不是句子的中心人物或 「主角」:在直4中, 'I don't like to play with him.' 的主角是I(我),是我不喜歡與誰玩,句子説出我自 己的喜好,而不是Tom的喜好。

横5也是以「我」自己為中心,是「我」喜歡與媽媽 談話,句子説出我喜歡甚麼,而不是媽媽喜歡甚麼。

横12的「主角」則是老師Mr. Chan,是他給我們書 本,我們是接受他的書的人。

凡是句子中的「配角」都不能用he、she、we、I和 they,而要用him、her、us、me和them。

備

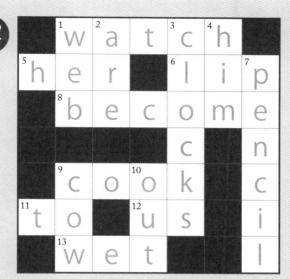

Guest: There is a fly in my soup!

Waiter: Surely not, we keep them for our

hamburgers!

(客人:我的湯裏有一隻蒼蠅!

侍應:怎麼會,我們把牠們留給我們的漢堡包

嘛!)

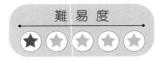

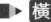

- 1. 向着;朝某一個方向
- 7. 遙遠
- 8. 看見
- 9. 媽媽(英式口語)
- 11. 它
- 13. 一種很著名的塑膠積木
- 15. Sam is my classmate. _____ is thin.
- 16. 街道的眾數

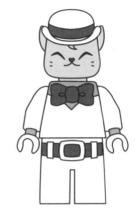

12200	45079000
965070	Cherry
200	55 55
5600	- III III
2000	500

- 2. ____course! (當然可以!)
- 3. am的過去式
- 4. You _____ a clever boy.
- 5. _____ homework (做家課)
- 6. 火腿
- 10. Dogs are our friends. They can make _____happy.
- 12. 腳趾的眾數
- 14. 或;或者

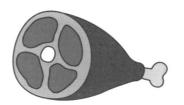

T	1	2	3	4		5
6		7				
			8			
9	10				11	12
			13			
		14			15	
16						

很多時候,當我們不想重複説過的人或物件時,便可 以用it和he,例如:

- ★ The cat belongs to me. It is cute. (這隻貓是我的。牠很可愛。)
- ★ That man is a fireman. He is Tom's father. (那男人是消防員,他是湯姆的父親。)

直5

用do來做的事情有很多,除了做家課外,較常用的 有:

- ★ do housework (做家務)
- ★ do sports (做運動)
- ★ do a sum (計數)

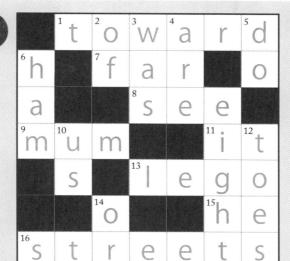

LEGO 積木玩具的創辦人原來是丹麥的 Ole Kirk Christiansen 和 Godfred Kirk Christiansen 父子,LEGO是兩個丹麥字 Leg 和 Godt 合併而 來的,意思是 play well(好好地玩),後來,

他們才發現原來 LEGO 在拉丁文中是解作 I put together,即「合起來」。

起初,LEGO 只是一家擁有10名員工的小公司。時至今日,LEGO 已為全世界小朋友認識,伴隨不少小朋友成長。你知道 LEGO 也建成了像迪士尼樂園一樣的兒童樂園嗎?原來在丹麥、英國、荷蘭和美國等地都有 LEGO LAND (樂高樂園),樂園主要由 LEGO 砌成,在 LEGO 的原產地丹麥的 LEGOLAND 內,便設有迷你小人國和包羅萬有的機動遊戲。單是小人國便用了 200,000,000 塊 LEGO,大家可以見到用 LEGO 砌成的風車轉動和飛機起飛,十分有趣!

- 1. 朋友的眾數
- 5. 也;又(He likes sweets. I like sweets 他喜歡糖果。我也喜歡。)

- 8. 每一個
- 10. 指甲
- 12. see的過去式

直

- 1. 農夫的眾數
- 2. 新界區的縮寫
- 3. 門
- 4. 因此;所以
- 6. site (網址)
- 7. 平坦;平滑
- 9. 蛋黃
- 11. _____ orange

				2	2	,
1				2	3	4
			3.7	5		
			Control of the			
		6	7	1431		
		8				9
				Titles.		
	217					
			10	11		
	1 2 6 7 0 3					
12						
			100			

橫1

friends除了是朋友的眾數外,也可解作與 某人做朋友,但句子必須包含make:

★ I made friends with Susan. (我與蘇珊做了朋友。)

橫8

every通常與其他詞語一同運用,配上不同的名詞便 會產生不同的意思,例如:

- ★ every day / everyday (每一天)
- ★ everyone / everybody (每一個人;人人)
- ★ everything (每一件東西;所有東西)
- ★ everywhere (每一處地方)
- ★ every night (每一晚)
- ★ every Saturday (每一個星期六)

直2

香港的新界區是The New Territories,為了方便書寫, 人們一般將它寫成N.T.。

直7

even有很多意思,你知道2、4、6、8、10等雙數(偶數)數字是叫做even number(s)嗎?在本書的其他考驗中你還會碰到其他意思呢。

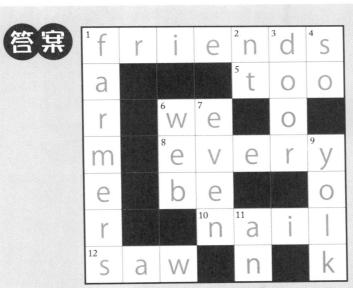

難易度

▶横

1. 穿過;經過

5. 頭髮

6. 奇怪;怪異

7. 一個女孩子的名字

8. 大猩猩

10. 哈(笑聲)

11. 旅行的眾數

2. have的過去式

4. 母雞

7. 全部

9. 美術

1	2	3		4
5				
6			7	
8				9
10				
11				

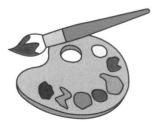

橫10

表示聲音的詞語有很多,例如:

- ★ boom (隆隆 打雷聲)
- ★ tick-tock (滴答—— 大時鐘運作時的聲音)
- ★ chirp (唧唧 小鳥的叫聲)
- ★ miow (英式)、 meow (美式) (喵 — 貓的叫聲)
- ★ woof (汪 狗的叫聲)

適當運用這些詞語可以令你的文章更生動啊!

直9

美術是不可數的,因此沒有眾數;但art可以加上 s,arts是指文科,包括語文、歷史、地理和哲學等 科目。

662

¹ t	² h	3 	0	U	g	⁴ h
⁵ h	а	i	r			е
6 O	d	d		a	n	n
U		е				
⁸ g	0	r	0			⁹ a
¹⁰ h	a					r
¹¹ t	r	i	р	S		t

原來英語中也有用「毛管戙」來形容人們受到驚嚇,make your / my / his / her / their / our hair stand on end 的字面意思便是令你 / 我 / 他 / 她 / 他們 / 我們的頭髮豎起,即是毛骨悚然,我們不是時常可以見到卡通人物有這樣的表現嗎?

難易度

▶横

- 1. 花灑浴 / 淋浴
- 5. 筆;鋼筆
- 6. 邊緣的眾數
- 8. 戰爭
- 9. 擲;拋
- 11. _____ a movie
- 12. 打;擊

V E

- 1. There are _____ many eggs. I can't eat them all.
- 2. 操作
- 3. 結婚
- 4. 英語
- 7. 兒子
- 8. He _____ the race. (他贏了比賽。)
- 10. Do, re, mi, fa, so, la, ______

1		2	3	4		
		5				
	i	6				7
8						
		9			10	
11				12		

我們「洗花灑浴」或「淋浴」通常是have / take a shower o

直4

English除了解作英語,也可代表英國人(但前面必 須加the) ,和所有與英語及英國有關的事,例如:

- ★ I can speak fluent English. (我能夠說一口流利的英語。)
- ★ The English live on an island. (英國人住在島上。)
- ★ I have an English dictionary. (我有一本英語字典。)

直10

在la之後的音通常都寫作te,原來除了te之外,也可 用si。Si是較少人會使用的寫法,其實它是從意大利 文Sancte Iohannes轉過來的法文,與te是相通的。

¹ S	h	2	3 W	⁴ e	r	
0		⁵ p	е	n		
		⁶ e	d	g	е	⁷ S
8	а	r				0
i		а		i		n
n		t	0	S	¹⁰ S	
11 S	е	е	1000	¹² h	ì	t

小笑話

'Why do the English love tea so much?'

'Try their coffee and you will know.'

(「為甚麼英國人那麼愛喝茶?」

「試試他們的咖啡,你便會明白了。」)

**這個笑話是諷刺英國人對弄咖啡完全不在行。

- - 1. 可怕的
 - 4. There are 30 persons in our class. Most of _____ are boys. (我們這一班有30人,大部分是男孩子。)
 - 5. 香口膠
 - 6. 梨子
 - 7. 搖搖(也稱「悠悠」或「溜溜球」)
 - 10. 幫助;援助
 - 13. 凳子的眾數

- 1. 拯救
- 2. 憤怒
- 3. 好味道
- 6. 豌豆的眾數
- 8. 油
- 9. 公牛
- 11. 'Is it difficult to learn English?' 'No, ____ is easy.'
- 12. 'You don't like that, you?'

			4			
	1		2		3	
					4	
			5			
6						
			7	8		9
10	11	12			è	
13						

三個很常用的短句:

Most of us =我們大多數人

All of us =我們全部人

Some of us =我們有些人

橫5

嚼香口膠是chew gum,不是eat gum。

橫7

yoyo寫作yo-yo。

直12

有時候我們會「明知故問」來再確定一下一些資料,例如'You don't like that, do you?'(你不喜歡那個,對嗎?),問的人老早知道對方不喜歡那個,想再得到對方肯定而已。

以下是一些常用的「明知故問」句式,注意劃有底線的字如何變化:

- ★ She <u>doesn't</u> eat fish, <u>does</u> she? (她不吃魚的,對嗎?)
- ★ She <u>eats</u> fish, <u>doesn't</u> she? (她吃魚的,對嗎?)

- ★ She <u>didn't</u> go to your party, <u>did</u> she? (她沒有去你的派對,對嗎?)
- ★ She <u>went</u> to your party, <u>didn't</u> she? (她到過你的派對,對嗎?)

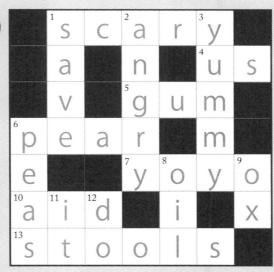

你知道嗎

世界之最

- ◆世界上最重的梨子有多重? 答案是6磅8安士(約六大袋方包的重量), 它是由日本愛知豐田梨子部所種的。
- ◆美國人Hans Van Dan Helzen用搖搖在 1 分 鐘內玩出 54 種花式,在 2005 創下了世界 紀錄。

難易度

▶横

- 1. 水喉
- 3. 難過;傷心
- 5. 酒吧
- 6. 加
- 7. 用來聽東西的器官
- 8. 小而圓的甜麵包
- 9. 著名兒歌歌詞:
 Head and shoulders,
 knees and _____s
- 11. No的相反
- 12. 人類的好朋友

首

- 2. 父親和母親
- 3. 開始的過去式
- 4. 爸爸 (口語)
- 8. _____scout (男童軍)
- 10. 蛋

熱身篇準備升級

過渡篇

準備升級

挑戰篇

索引

1	2		3	4
		i i		
5			6	
	7			.
8		4	9	10
11			12	
		A CONTRACTOR OF THE PARTY OF TH		

直3

有不少動詞在轉成過去式時只需加ed,常用的有:

happened (發生)

crashed (撞;崩塌)

smiled (微笑)

laughed (大笑)

shouted (叫喊)

walked (步行)

played (玩)

asked (問)

reply→replied (回答;回應)

answered (回答)

listened (聆聽)

cooked (煮食)

washed (洗)

cleaned (清潔)

finished (完結)

guessed (猜)

這類動詞屬於「規則動詞」(regular verb)。

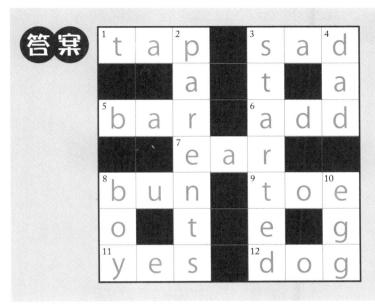

除了直3,格子內有另一個動詞也屬於左列的類別,你猜到是哪一個嗎?

難易度

- 1. 打破;打碎
- 5. ____soup
- 6. 聽到
- 8. 敬畏
- 10. 'Do you like ice cream?' , I don't.'
- 12. 撕破;扯碎
- 13. She is _____ ing loudly. (她正在很大聲的説話。)

- 9. 弱
- 11. 吃東西的過去式

And the second	1	2		3		
4		5				
6						7
				8	9	
10			11			
			12			
	13					

如果用湯匙喝湯,英文的講法是 'eat soup with a spoon',在這情況下,不可用'drink'代替'eat',但如果拿起整個碗來喝的話,就可用'drink'了。

橫6

hear =聽到,通常是無意中的 listen =聆聽,是專心去聽 例句:

- ★ I am listening to music. (我在聽音樂。)
- ★ I can hear a voice in the next room. (我可以聽到隔壁傳出一個聲音。)

直4

China也可解作瓷器。由於中國是瓷器之鄉,故西方 人便索性叫中國做瓷器。

	¹b	² r	е	³ a	k	
⁴ C		⁵ e	а	t		•
⁶ h	е	а	r			⁷ b
i		d		⁸ a	9 W	е
10 N	0		¹¹ a	r	е	а
а			¹² t	е	a	r
	13 S	р	е	а	k	

Tom tells his teacher: I'm sorry, Miss Lee, I've only copied twenty lines of 'I must keep quiet' because my pen squeaked very loudly while I was writing. And my father shouted 'can't you keep quiet!'

... 500 L 90 Cheles 200 Cheles 20

(湯告訴他的老師:對不起,李老師,我只是 抄了20句「我要保持安靜」,因為我一邊罰 抄時,我的原子筆一邊吱吱地叫得很厲害,我 的爸爸叫道:「你可不可以保持安靜!」) 準備升級

▶ 横

- 1. 數據
- 4. 機械人
- 7. 行人路
- 8. 它自己。例句:The squirrel wraps its tail around _____. (那隻松鼠將尾巴圍着自己。)
- 12. button (解開鈕扣)
- 13. 第二

- 1. 'How _____ you ____?
- 2. 缺席
- 3. 東方
- 4. 咆哮
- 5. 多種體育活動
- 6. Sue knocked on the door and said, 'May I come _____?'
- 9. _____day(星期日)
- 10. 終點;末端
- 11. 瘦的相反

		1	2				3
	4						
5						6	
7		V					t
		8		9	10		11
				12			
13							

將un加在某些詞語前會造成一個新的字,表示與該詞語相反的意思,例如:

- ★ do(做了)→undo(解開;解除)
- ★ sure (肯定) →unsure (不肯定;沒有信心)
- ★ dress (穿上衣服) →undress (脱去衣服)

例句:

★ I undid the buttons.

(我解開扣子。)

★ She is unsure of herself.

(她對自己沒有信心。)

★ He undressed and went to bed.

(他脱去衣服後上床睡覺。)

a

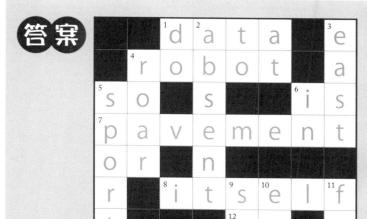

▶横

- 2. 買東西
- 4. 身體
- 6. You are _____ good! (你是那麼好!)
- 7. 叫人安靜時所發出的聲音
- 9. secondary ____ (中學)
- 10. was 的現在式。例句:I _____ a boy.
- 11. _____ careful! (當心)
- 12. _____ quiet! (保持安靜!)
- 13. to _____(今天)
- 14. 茶杯

直

- 1. ____ to bed
- 2. I go to school _____ tram.
- 3. 波板糖
- 4. 靴子
- 5. 迪士尼
- 7. 搖動;震動
- 8. 家

11. good的相反

**	1		2				3
4		5				6	
				⁷ S	8		
	对 非	9					
				10			i
	11			12			
13							
					14		

以下是一些常用的與keep字連用的命令語:

Keep out! (不准進入!)

Keep it secret! (保守秘密!)

Keep on! (繼續!)

橫14

如果在餐廳想叫一杯茶或咖啡,可以說'May I have a cup of tea / coffee, please?',如果想要兩杯便說 two cups of coffee,cup前面加數字,便表示你想要的數量了。

直7

奶昔的英文名便是milkshake,由於製作這種飲品時須要將奶和雪糕等搖搖搖,直至變成泡沫狀,所以用shake字最為貼切不過。

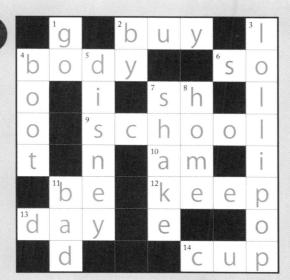

華特迪士尼先生是一個工作非常認真和嚴謹的人。《雪姑七友》(Snow White and the

Seven Dwarfs)是世上第一齣動畫電影,迪士尼用了3年時間(1934-1937),750個畫師,及5個導演來製作這齣電影,平均每人每

天工作 15 小時!

當電影在美國紐約上畫後,迪士尼先生仍在修改王子的動作,他會立刻將最新的版本送到戲院,由此可見他工作是多麼 投入和認真!這種精神很值得我們學習呢!

- 1. 小飛俠的名字
- 5. 海
- 6. did的現在式
- 7. 貓的眾數

- 10. _____ front of
- 11. 桃
- 13. 雀鳥棲息的地方(如樹枝)
- 15. 星期六

- 1. 布丁(一種甜品)的眾數
- 2. 逃走
- 3. 讀物
- 4. 輕拍
- 8. 這麼;這樣的。例句: I have never seen
 _____ a tall building.
 (我從來未見過這麼高的建築物。)
- 12. 酸性液體

628	CHICAGO CO.
93700000	
1005605	98 B
	25 E
40000	Mary and and

13. 寵物

14. I did it _____ myself. (我自己做的。)

1			2	3	4		
	ert.		5				
6			7			8	
		9					
10			11		12		
		¹³ P			C		
							14
15					d		

横5

與海有關的東西可以直接將sea加在開頭,以下是一些常見的詞語:

seafood (海鮮)

seasick (暈船浪)

seahorse (海馬)

seagull (海鷗)

seaside (海邊)

sea lion (海獅)

seaweed (海草)

橫7

我們很多時聽人形容大雨是「落狗屎」,在英文中也是用狗,不過是「連貓和狗也落下來了」,即it is raining cats and dogs.

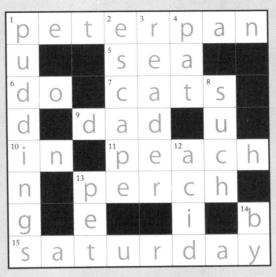

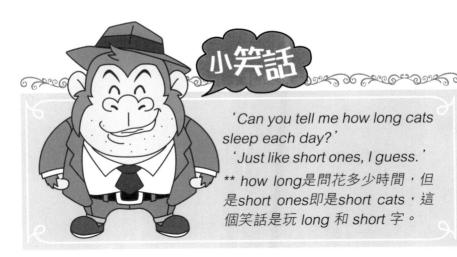

難易度 ★★◆◆

▶ 横

- 1. 狗吠
- 3. I _____ happy.
- 4. 罐頭
- 5. He _____ talking to me.
- 6. _____ Monday
- 7. _____ eleven o'clock
- 9. 剝光豬
- 12. yes的相反詞
- 13. 女孩子
- 14. basket
- 16. 美國城市洛杉磯的簡稱
- 17. I want _____ go ____ the toilet.
- 18. I have many _____ for the future. (我未來有很多計劃。)

- 1. 一種猴子愛吃的水果
- 2. 小孩子
- 7. 每個人每一分鐘都需要的

8. You should not _____ lies.

(你不應該説謊。)

- 10. 捲
- 11. 薄餅
- 14. 球拍
- 15. 膝

	1			2		3	
⁴ C				5		+ + 10	
6					i de la companya de l	7	⁸ t
9		10 r			11		
	12			13			
14			15				
		16					
17			18				

横5

'He is talking to me.' 一句運用了現在進行式(present continuous tense)。當你想説明現在某一時刻正 在發生的事的時候,你便要運用這個時態了。例如:

★ I am doing homework now.

(我正在做家課。)

★ Look! The bus is coming.

(看!巴士來了。)

横6 横7 横17

on是介詞(preposition),介詞包括on, at, in, above, of, behind, by, to, under等等。它們可以用來指出事 物的位置、時間性和與其他事物的關係。例如:

- ★ on Monday (在星期一)
- ★ at eleven o'clock (在十一時)
- ★ I went to Australia last year. (我去年去了澳洲。)

注意:凡是用在日子前的介詞都必須是on,時間前的必須 是at,而to通常是指到某處地方。

洛杉磯的全名是Los Angeles,簡稱須寫大楷LA,因為地名是專有名詞。

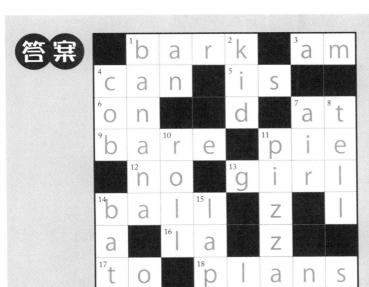

The student said: I'm sorry, so am I!

(校長遲了一個小時回校。他在校門撞到一

個學生,那個學生時常遲到。

校長説:「又遲到!」

學生說:「很抱歉,我也是!」)

難	易	度

▶ 横

- 2. She has a handbag. The handbag is _____. (她有一個手袋。手袋是她的。)
- 4. 但是
- 7. 支持
- 10. 小蝦
- 11. the _____ beautiful (最漂亮的)
- 13. as soon _____(儘快)
- 14. 修改

- 1. 磨菇
- 3. 學生稱呼男老師時用的
- 5. take _____(輪流)
- 6. 郵票的眾數
- 8. 下午的簡寫
- 9. 張開;商店開業
- 10. 總數;加數的和
- 12. seven, eight, nine, _____
- 13. _____ ant ; ____ umbrella

熱身篇/準備升級

	1		2			3	
4		5					6
	7			8	9		
10 S			•				
11			12				
						13	
14 a					14.7.7.7. 14.7.7.7.7.7.7.7.7.7.7.7.7.7.7.7.7.7.7.7		

直8

p.m.是取拉丁文post meridiem首兩個字母而成的,在 英文中,有很多取兩個至數個英文字的首字母而成的 簡稱,以下是一些常用的例子:

- ★ the United Kingdom—the UK=英國
- ★ the United States of America→ the USA / US=美國
- ★ World Trade Organization→ WTO=世界貿易組織
- ★ Hong Kong→H.K.=香港
- ★ National Basketball Association → NBA=美國職業籃球協會

直第4行第3格

pi是圓周率,是圓形的邊長除以它的直徑所得出來的,約為3.14,當你們升上中學後,便有機會利用圓 周率解決一些數學問題。

	m		²h	е	r	³ S	
¹b	U	⁵ t					⁶ S
	⁷ S	U	р	⁸ P	90	r	t
10 S	h	r	ì	m	р		а
u	r	n			е		m
¹¹ m	0	S	¹² †		n		р
	0		е			¹³ a	S
¹⁴ a	m	е	n	d		n	

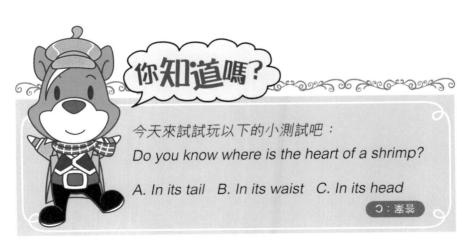

| |----

. . .

~ ~

- -

....

- -

. . .

難易度 ★★★☆☆

▶横

- 1. 醫生
- 3. _____-operate (合作)
- 4. 如果
- 5. 垃圾箱
- 6. 恐龍
- 9. 號碼的縮寫
- 10. 用具;工具
- 11. Those dolls are lovely. I like _____.
- 12. My birthday is _____ October.
- 13. Birds chirp, lions _____.

- 1. _____ housework (做家務)
- 2. This box is made ____ wood. (這個盒是木造的。)
- 3. 小雞
- 5. 船
- 7. 在下面
- 8. 房間
- 11. I want _____ draw a picture.

co通常用來放在一個字的開頭,有「一同」的意思, 例如:

- ★ co-author (合著人)
- ★ coexist (並存)

構9

號碼的全寫是number,當縮寫時,no後要加一點,即no.。

檔10

工具通常配合其他詞語一起使用:

- ★ teaching kit (教學工具)
- ★ fishing kit(釣魚工具)
- ★ first-aid kit (急救工具)

直第6行第1格

Tina是女孩子名。

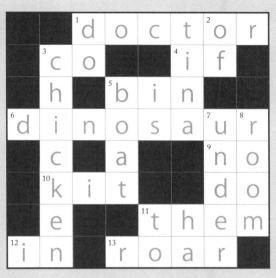

業易度
★★★◇◇

横

- 1. Jenny _____ the door two minutes ago. (珍妮在兩分鐘前關上門。)
- 4. Do you have any brothers _____ sisters?
- 5. 啜飲
- 6. 島
- 9. _____ is raining.
- 10. I like reading. Reading _____ fun.
- 11. low(低)的相反
- 12. ____ sky
- 13. 男孩子名
- 14. 市鎮

直

- 2. 陽光
- 3. up的相反
- 5. 一種服裝的眾數
- 7. 灰燼
- 8. 排水管;溝渠
- 11. 布的邊緣

	1		2		3	
	***				4	
5						
		6		7		8
9			10			
		11				
12						
13			14			

你們有沒有留意店舖關門時會掛出closed的牌子?如果我們要告訴別人店舖關門了,便要說 'The shop is closed.'。closed變成了形容詞而不是動詞。

橫12

- 一些在世上獨一無二的東西都會用the,例如:
 - ★ the sun (太陽)
 - ★ the moon (月亮)
 - ★ the earth (地球)
 - ★ the sea (海)
 - ★ the air (空氣)
 - ★ the wind (風)
 - ★ the stars (星星)

橫14

離開家或工作崗位一段短時間可以說 'out of town',例如:

★ Mr Chan is out of town.

(陳先生不在家。)

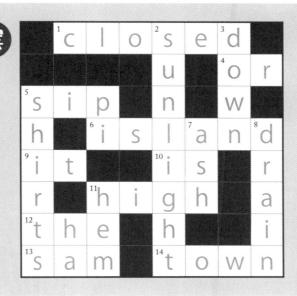

▶横

- 1. 練習;運動
- 4. went 的現在式
- 7. 雲的眾數
- 10. _____ corn (爆谷)
- 11. 鋸
- 13. 前夕
- 14. 提供酒的小旅館
- 15. 和金

直

- 1. _____ shell(蛋殼)
- 2. I live _____ Hong Kong.
- 3. Don't _____ too much fat. It is unhealthy.
- 5. 小丑
- 6. 超級的;很出色
- 8. 白鴿
- 9. _____ money (花錢)
- 11. _____ months = half a year

12. _____ envelope

16. This bag belongs _____ me.

1				2		3
4						
		5	6			
	7			8	9	
			10			
11	12		13			
14			15			16

直6

super可以放在名詞和形容詞開頭,與它們結合後變成一個新的詞語,例如:

- ★ super + man = superman (超人)
- ★ super + market = supermarket (超級市場)
- ★ super + star = superstar (超級巨星)
- ★ super + natural = supernatural (超自然)

還有很多名詞和形容詞可以與super結合,我們甚至可以自創新詞呢!

直9

spend除了可以用於花費金錢,也可用於花掉時間,例如:

★ He usually spends a lot of time studying for the exam.

(他通常花很多時間來預備考試。)

★ I spent thirty minutes on/doing this. (我花了30分鐘來做這件事。)

¹e	X	е	r	С	2 •	S	³ e
⁴ g	0				n		а
g		⁵ C		⁶ S			t
	⁷ C		0	U	^{8}d	⁹ S	
		0		¹⁰ p	0	р	
¹¹ S	¹² a	W		¹³ e	V	е	
14 •	n	n		15 r	е	n	¹⁶ t
X						d	0

Doctor: What exercise do you do?

Patient: Many - swimming, running, bad-

minton ...

Doctor: How often?

Patient: Not yet. I'll start tomorrow.

(醫生:你做甚麼運動?

病人:很多——游泳、跑步、羽毛球……

醫生:多久做一次?

病人:還未。我明天開始做。)

- 1. He is the only one who _____ the competition. (他是唯一一個參加了比賽的人。)
- 4. Pa _____(爸爸)
- 5. He told the puppy _____ go home.
- 6. 硬殼果
- 7. _____ -count (重新計算)
- 8. 小神仙
- 10. 四月
- 12. 一個女子名
- 13. The birthday cake is made _____ Mum.
- 14. 性别
- 15. My father works _____ Queen Mary Hospital.

首

- 1. 一月
- 2. 興趣
- 3. 'How many pencils _____ you have?'
- 5. 電話的縮寫
- 7. 鬆弛;放鬆

- 9. 渡海小輪
- 11. 香港專業教育 學院的縮寫

	1		2				3
4						5	
	6				7		
					8		9
	10			11			
			12				
13			14				
		15					

參加比賽、加入興趣小組或學會都可以用join,例如:
★ I join the drama club. (我加入了話劇學會。)

檔4

Papa是小孩子的説話。

橫7

很多時候,我們會將re加在一些動詞前面,表示再做一次該動作,例如:

- ★ re + use = reuse (再用)
- ★ re + tell = retell (再説;復述)

直5

Tel後面是要有一點的,即tel.。

直11

IVE的英文全名是Hong Kong Institute of Vocational Education,vocational是解作與職業有關的,IVE設有很多小學沒有的科目呢,包括鐘表設計、時裝設計等。中六畢業的大哥哥大姐姐都可以入讀IVE。

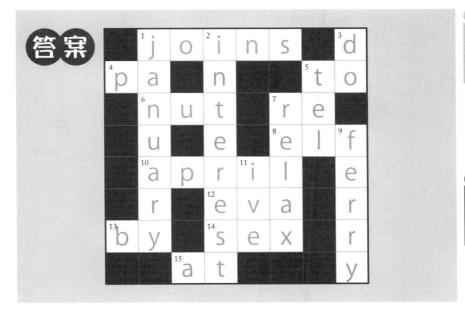

- 1. 慢的相反
- 5. 槍
- 6. 墨水
- 7. six plus two is _____
- 9. 打賭
- 10. _____ ober (一個月份)
- 12. ' _____ do you think?' (「你的意見如何?」)
- 16. 一個人
- 17.7 (七喜汽水)

首

- 1. 皇后
- 2. _____3 (課文的第三課)
- 3. 廚房
- 4. 「很好」、「無問題」的口語
- 8. '____ much is it?' 'Ten dollars.'
- 11. 柏油
- 13. 陷阱

	5389	Section and
A 1 = 1		
	100	

- 14. 炒東西
- 15. His look is the same _____ his brother's. (他的樣子長得和他兄弟一模一樣。)
- 16. 「家長指引」的縮寫

	1	2			3		4
5					6		
	7			8			
9				10		11	
				12			13
		14	15				
16							
						17	

與「八」有關的東西很多都是oct作頭的,例如:

- ★ octopus (八爪魚)
- ★ octagon (八角形)
- ★ octave (八度音階)

October (十月) 則是例外。

直2

unit其實是一個組織、系統或社會裏的一個單位,例如:

★ The kilogram is a unit of weight.

(千克是重量單位。)

所以,我們說第幾課第幾課的那個unit ,便表示該書本裏的其中一個單元。

直4

OK必須是大楷,而OK與okay是相同的。

直16

「家長指引」的英文全寫是 'Parental Guidance'

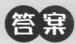

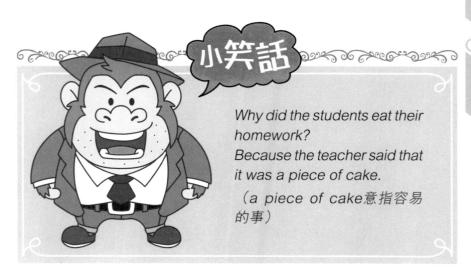

難	易度	
**		

▶横

- 1. He is _____ fat that he can't go through the door. (他太胖了,沒法通過門口。)
- 2. Mary teaches evening classes _____ night.
- 4. 'Let's _____ swimming!'
- 7. A smaller box is put _____ a bigger box. (一個較大的盒子內放了一個較小的盒子。)
- 8. 人們
- 10. 坐
- 11. 跑的過去式
- 13. 沒有任何東西

- 3. 票
- 4. 薑
- 5. 河
- 6. She _____ with the housework. (她幫忙做家務。)
- 9. 獅子
- 12. _____ elephant

	1				2	3
4			5	6		
7						
		8			9	
				10		
11	12					
	13					

at字的用途很廣,例如節日:

- ★ at the Mid-Autumn Festival (在中秋節)
- ★ at Christmas (在聖誕節)
- ★ at Easter (在復活節)

在一些特定的時刻也會用at,例如:

- ★ at dawn (破曉)
- ★ at the beginning (開始時)
- ★ at the end of ... (在……完結時 / 的結尾)
- ★ at ten o'clock (在10時正)
- ★ at weekends (在週末)

一些較小的城鎮、有街號的住址和某些建築物也會用 到at,例如:

- ★ I live at 20, King Street. (我住在皇帝街20號。)
- ★ I live at Sheung Shui. (我住在上水。)
- ★ at the City Hall library (在大會堂圖書館)
- ★ at the cinema (在戲院)

橫7

inside告訴我們一件東西在甚麼地方,現在讓我們看 看其他告訴我們某東西的位置的詞語吧:

outside(在外面),例句:

★ There is a chair outside the classroom. (課室外有一張椅子。)

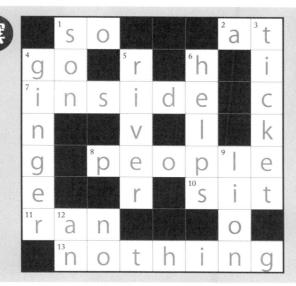

above(在較高處),例句:

★ The bird is flying above the tree.

(小鳥正在樹的上方飛。)

under(在下面),例句:

★ The cat is sleeping under the table.

(貓兒在桌子下睡覺。)

between(在兩者中間),例句:

★ Between the school and the library is the hospital. (在學校和圖書館之間是醫院。)

你知道嗎

在聖誕節的時候,西方人喜歡弄薑餅(Gingerbread)吃和製造薑餅屋作裝飾,薑餅的味道甜 甜的,通常會做成一個個人仔或心形等形狀,薑 餅屋上會加上不同的糖果,既可愛又美麗。

60.30 4 90 4.00.30 4 90 4.00.30 4.30

難	易度
**	

▶横

- 4. 詩歌
- 6. He is _____ fat. He should do more exercise. (他太胖了。他該做多些運動。)
- 7. 'Have you _____ been to Japan?'
 'No, never.'
 (「你到過日本沒有?」「從來沒有。」)
- 8. She ____ up at 8 o'clock yesterday.
- 10. the first _____ ner-up (第二名)
- 11. 托盤
- 12. 裂縫;缺口

V E

- 1. Do _____ litter! (不要亂拋垃圾!)
- 2. Don't _____ shy! Speak louder.
- 3. 足印
- 4. 詩人
- 5. 早上
- 8. 山羊
- 9. 嘗試

			7	
			3	
	Y	To the second	1	7
×	X	林	林	X
×		$\stackrel{d}{d}$	$\frac{1}{1}$	*

1			2		3
	4			5	
6					
	7				
8					
		9			
		10			
11				12	

the second runner-up是第三名,第一名可叫作winner。並不是所有有'first'的詞語就是解作第一啊!

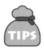

直5

向人説早晨可以説Good morning或只説Morning; 一個星期中的某一個早上便是on Saturday morning(在星期六早上)或 on Thursday morning(在 星期四早上)。

a

0

S

Susan told her classmate John: Last night my mum had a quarrel with my dad. My mum was very angry. She told my dad that she didn't want to see him any more.

John: Then what did your father do? Susan: My dad said, 'Switch the light off!'

(蘇珊告訴她的同學約翰: 昨晚媽媽和爸爸 吵架,媽媽很生氣,她向爸爸説她不想再見 到他。

約翰:那麼你的爸爸怎樣做?

蘇珊:爸爸說:「把燈閣掉吧!|)

- 1. 擦膠
- 5. My dog _____ orders. (我的狗服從命令。)
- 7. pick flowers in the park!
- 9. The game is ___ (游戲完了。)

11. 傻笑;咯咯地笑

- 2. 泡沫
- 3. 回答; 反應
- 4. a box ____ chocolates (一盒巧克力糖)
- 6. We sing the song _____ with our teacher. (我們和老師一同唱歌。)
- 8. 然後;接着
- 10. 小地氈

		-					
1		2			3		4
	5						
6							
				7		/	8
9			10			7	
11							
				1			

答案是Don't,即do not的縮寫。Don't放在句子的開 頭代表給予別人一項指示,在英語中,有很多動詞也 可以放在句子開頭,也代表給別人一項指示,例如:

- ★ Turn south. (轉向南面。)
- ★ Shut the door. (關上門。)
- ★ Read that book, John. (約翰,讀那本書。)

直8

當我們想告訴別人一些步驟時,例如教別人如何煮食 物或玩運動,我們便有需要用到then,通常亦會配合 其他字如first(首先)和next(接着),例如:

★ First, mix the egg with the flour.

Next, add some oil. Then, add some cold water.

(首先,將雞蛋和麵粉混合,然後,加入一些 油, 還有, 加入一些冷水。)

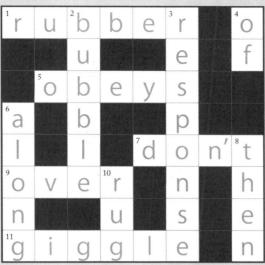

2. 你見過「泡泡碗」— bubble bowl — 嗎? 它原來是那種圓形的,有一個大開口的玻璃器皿,專門用來盛載—朵浮在水上的花朵。

- 2. 遮蓋
- 5. 獨奏;獨唱

- 7. 小型貨車
- 8. Miss Chan told us a story _____ the English lesson.
- 9. 獎品;戰勝品
- 12. 樹林

- 1. 樹葉的眾數
- 2. 不能夠
- 3. 訪客;旅客
- 4. 蜜糖
- 6. _____ the way (在途上)
- 10. 桿;棒
- 11. 乾草

1	2		3			
						4
			5	6		
7			8			
	9	10			11	
12						

書的封面是front cover, 封底是back cover。

直1

改過自新是turn over a new leaf。例句:

★ He has turned over a new leaf.He won't be late again.

(他已經改過自新,不會再遲到。)

直2

cannot後面的動詞必須是原形,例如:

- ★ She hasn't got the ticket. She cannot come. (她沒有票,不能夠來。)
- ★ It is raining. You cannot go out.

 (外面下着雨,你不能夠出去。)

 cannot 的過去式是could not,兩個字必須是
 分開的啊!

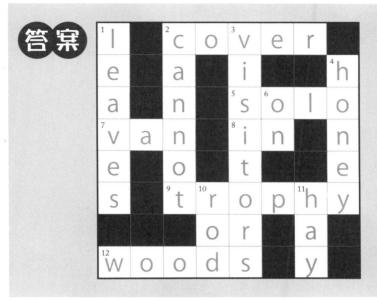

- 1. Stealing _____ a crime. (偷竊是罪行。)
- 5. 足夠
- 6. 種子
- 7. Johnny _____ I are friends.
- 9. 攻擊

- 2. 挑選
- 3. 泥
- 4. _____ did you go home last night?
- 8. 暗;朦朧
- 10. 小桶(指盛啤酒的桶)

直4

When是用來問時間的,我們問不同的事就要用不同的字,例如:

★ 問地方一

Where do you live?

(你住哪裏?)

★ 問東西(死物),例如食物、時間、衣服等—

What do you like to eat?

(你喜歡吃甚麼?)

What time did you go out?

(你甚麼時候出去?)

★ 問方法―

How do you go to school?

(你如何卜學?)

★ 問感覺—

How do you feel?

(你覺得怎樣?)

How did you find the book?

(你覺得這本書如何?)

★ 問原因—

Why are you late?

(你為甚麼遲到?)

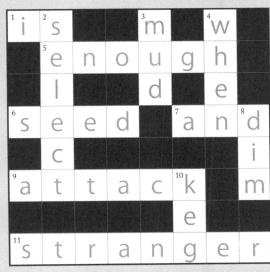

How could the French fry win the race? It was fast food!

(為何薯條會勝出比賽? 因為它是快餐。)

▶横

- 1. 加數的和
- 3. 一個人在單足跳
- 6. I have ____ uncle.
- 7. 怪物的眾數
- 8. 追捕;追趕
- 10. pay的過去式
- 12. 四周;環繞。

例句: The earth goes _____ the sun.

- 14. 拍攝電影時用來稱呼「不好的鏡頭」
- 16. I _____ the eldest in my family.
- 17. 一滴眼淚

- 1. 相似
- 2. 迷你
- 3. 孵化
- 4. Three minus two is _____
- 5. 姊或妹
- 9. 播種

10. 小孩子稱呼爸爸

11. 挖掘的過去式

13. 小點;圓點

15. 先生

	¹ S		2		3	4		5
	5							
					6			
	7							
		12.0		8			9	
10			11					
12					13			
		14 N						15
16					17			

橫14

經常聽到拍攝電影或電視時出現「NG鏡頭」,原來 NG是Not Good的簡寫,必須寫作大楷。

橫17

眼淚通常以眾數形式出現,因為哭總會流出多於一滴 眼淚,譬如説人哭便是in tears,例句:

★ He is in tears. (他在哭泣。)

直2

mini是一個「百搭」字,以下是一些與mini合體後的詞語:

- ★ minibus (小巴)
- ★ miniskirt (迷你裙)
- ★ minicomputer (袖珍電腦)
- ★ minidictionary (袖珍字典)
- ★ minicake (迷你蛋糕)

還有很多東西是可以與mini搭配的,你能夠想到多少呢?

|横

- 4 默書
- 7. 帶來或拿來
- 8. 小茅屋
- 10. 一個項目
- 12. 中間的
- 14. 罪
- 15. 撲克牌中的其中一款牌
- 16. 年
- 17. 座位

- 1. 日記
- 2. 對的
- 3. 'Come!' (「進來!|)
- 5. 噸
- 6. She always ____ with her mother. (她時常和母親爭辯。)
- 9. teach的過去式
- 10. 主意; 意念
- 11. 小姐
- 12. 五月
- 13. 冰

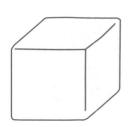

橫12

mid與mini一樣是一個「百搭」字,例如在香港島有 Mid-Level(半山區),那是中環與山頂中間的地區。 其他常見的詞語包括:

- ★ midnight (午夜)
- ★ midday (正午)
- ★ Mid-Autumn Festival (中秋節)
- ★ mid-May / June (五月 / 六月中) *在月份前加mid代表在該月中旬

直11

Miss(首字母是大楷)是小姐的稱呼,另外,如果你 想向別人説你很掛念他/她,你可以説I miss vou,在 這裏,miss是掛念的意思。

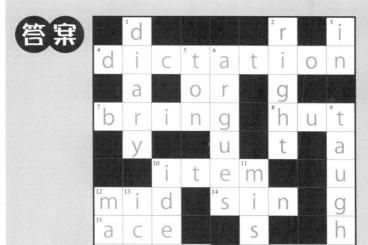

a

a

▶横

- 1. 選擇題:A doctor can be a man a woman. (and / or)
- 3. 發生
- 6. _____ have 20 boys in our class.
- 8. 鑽石的眾數
- 12. 一種外形像蛇的海產
- 13. _____ lash(睫毛)
- 15. noon (正午)
- 17. 輕叩
- 18. 一塊板
- 19. 年青

- 1. 貓頭鷹
- 2. 準備好
- 4. I _____ poor. I have no money.
- 5. 畫家
- 7. 遊戲
- 9. 旋律
- 10. 一步

- 11. taxi的同義字
- 14. 打呵欠
- 16. You like it? I like it _____

1	2		³ h	4	5		
6							
			7				
	8			9			10
11 C		12			13	14	
15	16				17 r		
18						W	
				19			

問人發生了甚麼事可以說 'What happened?'

問人「準備好了嗎?」可以說 'Are you ready?' 或 'Ready?'

直10

如果你想説你會加倍努力,可以説: 'I am stepping up my effort.'。Step up有加強數量和速度的意思。

級

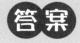

來試試這個小挑戰,看你對打呵欠的認識有多少。

- 1. Why do people yawn?
 - A.Because it is a kind of exercise.
 - B.Because the brains are working with some chemicals.
 - C.Both A and B are possible.
- 2. What animals also yawn?
 - A.Cats
 - B.Adelie Penguins
 - C.Both A and B are correct.

▶ 横

- 1. 嬰孩吃飯時用的圍嘴(廣東話是口水肩)
- 5. okay的同義字
- 6. 小息
- 7. match ____ (火柴的眾數)
- 8. 屋頂
- 10. 用來開鎖的東西
- 13. 'Have you _____ tried to make a cake?'
 'No, I have never tried to make one.'
- 14. Mum told _____ (my brother and I) that she love ____ (my brother and I).
- 15. 一種飲料
- 16. 萬聖節很多人扮的東西
- 18. 歌名: Stand _____ me
- 19. 一個週期

直

- 1. is的原形
- 2. 水的固體
- 3. 最好的
- 4. 駝鳥
- 5. 八爪魚

- 6. 火箭
- 9. quick的同義字
- 11. the day before a special day / festival
- 12. This _____ I am 20 years old. Next year I will be 21.
- 16. 小伙子的口語稱呼
- 17. 一種比水輕的液體

	1	2	3		4		5	
6								
		⁷ e						
					8			9
10	11	12					-	
13							14	
15				16		17		
18			19 C					

橫7

很多時候,h、x和s字尾的詞語在變成眾數時都要加es,例如:

- ★ boxes (盒子)
- ★ fishes (魚)
- ★ octopuses (八爪魚)
- ★ headmistresses (女校長)

横10

重要/關鍵的東西都可以用key來形容,例如:

- ★ key person(主要人物)
- ★ key point (重點)

直9

雖然fast和quick同樣解作「快」,但有些情況中人們 通常用fast而不是quick,例如:

- ★ Walk faster! (走快些吧!)
- ★ Annie is a fast learner. (安妮是一個學東西很快的人。)

guy是一個美式口語化的詞語,多用於稱呼平輩或後輩,例如:

- ★ Come on, guy! (來吧,小伙子!)
- ★ He's a nice guy. (他是一個好傢伙。)

難易度 ★★★★★

- 2. 出生
- 5. 星體的眾數
- 6. _____ is a boy.
- 7. A boy and I
- 8. _____ let (小豬)
- 9. 正在跳
- 12.藝術
- 14. Miss Chan is angry, _____ we keep quiet.
- 16. 水晶
- 18. I like him, he likes
- 19. Work hard _____ you will fail. (你要努力,否則你會不及格。)
- 20. _____ I were you I would buy that dog. (如果我是你,我會買那隻狗。)

首

- 1. 在這裏
- 2. 餅乾
- 3. 一行
- 4. 照耀(三身單數現在式)
- 5. 欠别人東西

- 8. 大頭針
- 10. 南極或北極的
- 11. 和暖
- 13. 裸麥
- 15. Turn _____ the fan. It is very cold.
- 17. I sent an e-mail _____ Tom last night.

橫2

説自己在某年出生必須要用過去式,例如:

★ I was born in 1987. (我在1987年出生。)

直3

如果你have a row(發音 $r\underline{a}\underline{v}$,與loud的發音 $l\underline{a}\underline{v}$ d相 近) with 某人,不是説你與某人有一行,而是與某人爭吵,例如:

★ I had a row with my sister yesterday.

(我昨天與妹妹吵架。)

Row也可以解划船。例如:

* Row the boat across the river!

(划船過河吧!)

(這個發音與一行、一列的row相同。)

直10

與南極和北極有關的東西都可以用polar,如果是名詞(動物或物種)與polar連用,便一定是與北極有關的。例如:

- ★ polar bear (北極熊)
- ★ polar star (北極星)

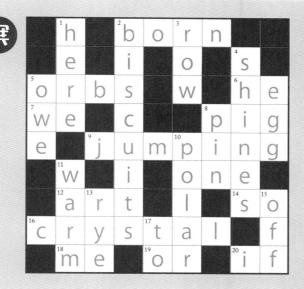

Why are polar bears so sad about taking photos?

Because they can never have a coloured photo.

(為甚麼北極熊對拍照那麼難過? 因為牠們永遠也沒有彩色照。)

. . . .

- -- --

- - -

. . .

- 1. 漁民
- 4. 生病
- 7. 人魚
- 8. Do _____ smoke.
- 9. 近的
- 10. 下陷
- 11. She always _____ clothes by herself. (她常常自己修補衣服。)
- 12. being 的原形

- 1. My father _____ work at 8 p.m. everyday.
 - (爸爸每天下午八時下班。)
- 2. 游泳(活動)
- 3. 發問
- 4. 姓氏
- 5. 外套
- 6. 給意見

準備升級

2					3	
		4		5		
						6
7						
		8				
9						
		11				
- 14 - 24 - 14	12					
	7	7	7 8	7 8 8	7 8 8 9 111	7 8 9

去游泳是go swimming,例句:

★ Let's go swimming this Saturday! (我們星期六去游泳吧!)

外套有很多種類,以下是其中一些:

- ★ raincoat (雨衣)
- ★ overcoat (大衣)
- ★ jacket (短外衣)
- ★ robe (寬鬆長袍)

勸告或建議別人做某事可以這樣説:

- ★ I advise you to read a book a day. (我建議你每天看一本書。)
- ★ The doctor advised him not to smoke. (醫生勸他戒煙。)

留意advise之後的那個動詞須要加to字。

1 f	i	S	h	е	r	m	a	n
i		W			11		S	
n		i		S	i	⁵ C	k	
i		m		u		0		å
S		m	е	r	m	а	i	d
h		i		n	0	t		V
е		'n	е	а	r			i
10 S	а	g		¹¹ M	е	n	d	S
		11	¹² b	е				е

你知道嗎? 童話故事《The Little Mermaid》(人 魚公主)是丹麥童話作家Hans Christian Andersen(安徒生)家喻戶曉的作品。安徒生 一生熱愛遊歷·他曾説:My life will provide the best illumination of all my works."(我的一生 為我的作品提供最佳寫照。)

安徒生多才多藝,他曾在劇團唱男高音, 又熱愛剪紙,他喜歡一邊向兒童說故事一邊剪 紙,到故事說完的時候便會如揭開謎底般張開 剪紙。2005年在安徒生先生誕生的200周年, 在他的家鄉Odense有不同的慶祝活動呢!

難易度
★★★★★

▶ 横

- 1. 鴨舌帽
- 3. hand _____(手袋)
- 5. 音樂
- 9. _____ body is here. There are only two of us.
- 10. 病了
- 11. 數枚硬幣
- 13. Jogging _____ good for your health.
- 14. 味道
- 16. _____ south; _____ north(南方;北方)
- 17. 鳥巢;巢穴
- 18. happy的相反

- 2. 拉(動作)
- 4. 草
- 6. 增加
- 7. 鴿子的叫聲

- 8. 一種手套,分成兩部分,一部分包着拇指,另一部分包着四隻手指
- 12. 晚上
- 15. 傳送

1		2			3		4
9	5		6	7			
8			9				
10			11			12	
						13	
14		15	1				
					16		
		17					
18							

紙幣是note,多於一張紙幣便是notes。

橫14

如果我們要說某食物好味道,可以說: It tastes good!

直12

向人説晚安便是Goodnight。

send的用途很多,包括:

- ★ 傳送電郵 = send an e-mail
- ★ 寄信 = send a letter
- ★ 發送短訊 = send a message
- ★ 寄明信片 = send a postcard
- ★ 送人入醫院 = send a person into hospital

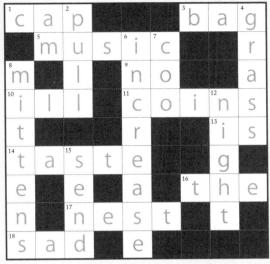

- 1. 薯仔的眾數
- 6. 在外面
- 7. 應付;處理
- 8. 咬
- 9. Swimming ____ my hobby.
- 11. We have a cat; He _____ a dog.
- 13. 在後面
- 17. 點燃的過去式
- 18. Those are shoes. Give them back to me.

直

- 1. 答應
- 2. 名稱或題目,例如書名、文章名及圖書名
- 3. 薄的相反
- 4. 大象
- 5. The building is _____ tall! I can't see its top.
- 10. _____ December 25th we go to parties.
- 12. 泥土; 土壤

14. 冷的相反

15. _____ I were you, I would give the coins to the beggar. (如果我是你,我會將硬幣給那個乞丐。)

16. 堤壩

A.T. A.E.	1		2		3		4	5
	1		2		3		7	3
							ē	
	6							
					7			
8								
9				10		11		12
13		14	15		16			
17					18			

直15

問題15是假設而沒有可能發生的,因為我們沒有可能 是對方,因此這句句子用了過去式,現試舉更多類似 的例子:

★ If there <u>were</u> two suns, the earth <u>would</u> melt.

(如果有兩個太陽,地球會溶化。)

★ If I were the king, I would travel around the world.

(如果我是皇帝,我會環遊世界。)

相反,有些事情是有可能發生的,這時候我們便會用 現在式,例如:

- ★ If you <u>eat</u> raw meat, you <u>will</u> fall sick. (如果你吃生肉,你會生病。)
- ★ If you <u>have</u> questions, just <u>ask</u> me. (如果你有問題便問我吧。)

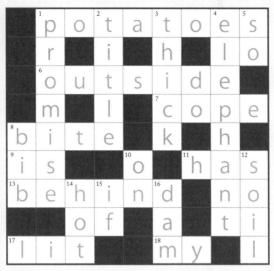

小笑話

以下是一些與大象有關的笑話:

- 1. What do you call an elephant that flies?
 A jumbo jet.
- 2. What do you get when you cross a potato with an elephant?

 Mashed potatoes.

- 1. I _____ a doll when I was young.
- 4. 合身的;合嫡的
- 6. 海豚
- 9. 介詞(preposition),可以表示將某東西放 在另一東西上面,例如:Put the plates the tray. (將碟子放在托盤上面。)
- 10. 針
- 12. 出口
- 15. 碼頭
- 16. 按里數計車資的 交通工具
- 17. 常春籐
- 18. 十幾歲的青年人

直

- 2. 形容詞
- 3. _____sports (做運動)
- 4. 魚翅
- 5. He walked _____ the post office. (他走進郵局。)

直

- 7. 梯子
- 8. 鋤頭
- 11. 雨
- 13. 'How much is it?' ' _____ is 18 dollars.'
- 14. 錄音帶

1	2	12				_		
1	2	3				4	5	
200000000000000000000000000000000000000	,							
	6		7		8			
					9			
10								
		100000						11
			12		13	14		
			12		13	11		
15				E 60 20 10 0	17			
13				2 445	16			
17								
18								

形容詞分成很多種類,包括:

- ★ 形容體積和長度的: small / large (小/大) wide / narrow (闊/窄)
- ★ 形容年齡的: old / young(老/年青)
- ★ 形容顏色的: orange (橙色) purple (紫色)
- ★ 形容特性或質量的: interesting / boring (有趣的 / 沉悶的) beautiful / ugly (美麗的 / 醜陋的)
- ★ 形容數量的: some(有一些,應用於可數和不可數的東西) many (很多)

用do來做的東西有很多,例如:

- ★ do martial arts (打功夫)
- ★ do magic tricks (變魔術)

go into是從外面走進裏面。如果你想説將某些東西放 進另一東西裏面也可用into,例如:

★ Pour the milk into the glass jar, please. (請將牛奶倒進玻璃瓶內。)

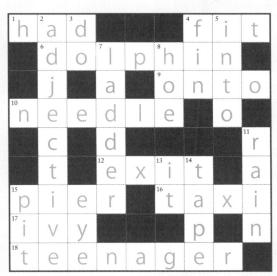

你知道嗎:

魚翅一般是鯊魚翅,在酒樓吃 到的魚翅羹便是叫作shark's fin soup °

▶ 横

- 1. 連字號,例如連接twenty和one的符號
- 4. 開心時發出的聲音
- 6. Don't sit _____ the table. It is impolite.
- 7. 英國的首都
- 9. _____ card (身份證的縮寫)
- 12. a _____ of (很多)
- 14. 乾的相反
- 15. mam _____ (媽媽,幼兒的口語)
- 16. 蠔
- 17. 禁止
- 19. 派對

- 2. 兜帽,「小紅帽|用的那種帽
- 3. 'Have you been to Japan?'

- 5. 獨個兒
- 8. 骯髒的
- 10. 瞬間
- 11. 擁有

13.柏油

18. I _____ the tallest girl in my class.

		1			2		3	
4	5						6	
	7			8				
				9			10	
11						12		13
14							15	
			16					
	17	18						
				19				

有時候,將兩個或多個本身沒關聯的字用hyphen連 成一起便會組成一個新字,例如:

- ★ phone-in(電台或電視台的一項節目,觀眾或 聽眾可以即場打電話參與)
- ★ person-to-person (一對一)
- ★ all-in-one (集多種功能於一身)
- ★ Mid-Autumn (中秋)
- ★ first-class (頭等)
- ★ record-breaking (破紀錄的)

身份是identity ,身份證是identity card。ID 是身份的 縮寫,必須是大楷。

a lot of可用於可數和不可數的東西,例如:

- ★ 可數的: a lot of people (很多人)
- ★ 不可數的:a lot of money(很多錢)

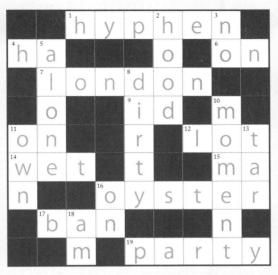

橫

- 1. 報紙
- 5. a vacuum _____ (吸塵機)
- 6. 領帶
- 7. 結他
- 9. 一碼(長度單位)

11. The children are _____ in the playground.

- 2. 熊貓
- 3. 港口
- 4. 記得。例句: My mother _____ the things I did when I was small.
- 7. 傢伙
- 10. 娛樂;玩樂;樂趣

1			2		3		4
		2.80 (15)					
5							
					6	V	
7		8					
9				10			
11							

玩樂器我們會用play這個動詞,例如:

- ★ play the piano (彈鋼琴)
- ★ play the guitar (彈結他)
- ★ play the flute (吹長笛)

fire(火)是不可數的,但是如果是指火災,則是可 數的,例如:

★ A fireman puts out fires. (消防員撲滅火災。)

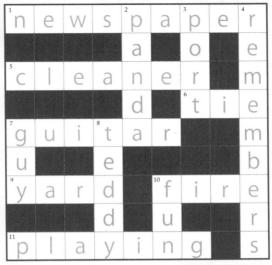

世上第一份報紙原來由Johann Carlous 於 1605年在法國和德國接壤的一個獨立城市 Strasbourg印製,Strasbourg現在是法國的 一個城市,那時候它是一個說德語的城市。

報紙的名稱是Relation aller fürnemmen und gedenckwürdigen Historien (Collection of all distinguished and commemorable news),意思是「著名的及值得紀念的新聞大全」。

- 1. 太空人
- 6. _____ the evening.
- 7. 'Come and join _____. Our team needs you!'
- 8. Dad goes to work _____ tram.
- 9. 污垢
- 11. _____ is a girl.
- 12. 'Don't go _____ that room. It is full of rubbish.'
- 13. 二十
- 16. Jane always _____ questions about animals.
- 17. 年龄
- 18. 'Whose pen is this?' '_____ is my pen.'
- 19. _____ hour

- 2. 數個學生
- 3. 鋼筆尖
- 4. 任何東西

- 5. give的相反
- 10. 植物的根(眾數)
- 14. l _____ soup.
- 15. 一種中國和英國人也 愛喝的飲料
- 16. _____ dinner time

1	2			3	4		5
				6			
	7			8			
	9	10					
				11			0
12							
		13		14		15	
16				17			
			18			19	

當你想問某東西是屬於誰人的時候,便可以用 whose, 問眾數的東西便說:

Whose pens are these? (這是誰的筆?) They are my pens. (它們是我的筆。)

首4

anything是一個十分有用的字,我們很多時候都會用 到它,例如:

- ★ I don't know anything about her. (我對她一無所知。)
- ★ I didn't eat anything because I was not hungry.

(因為我不餓,所以我沒有吃任何東西。)

★ You can buy anything you want. (你可以買任何你喜歡的東西。)

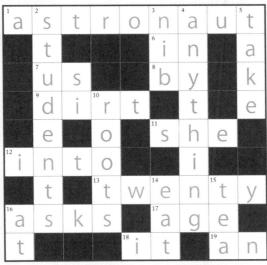

業易度 ★★★★★

- 1. 牆
- 3. 長袍
- 5. 盆;桶
- 7. 保護
- 8. 一個人
- 11. It is _____ correct, 即incorrect
- 14. 允許。

 例句: Father _____ me go to the cinema last night.
- 15. 金錢

- 1. 智慧
- 2. 圖書館
- 3. _____ a bicycle (騎自行車)
- 4. 一個樽
- 6. I get _____ at seven o'clock every morning.
- 8. swimming _____ (游泳池)
- 9. Mary puts _____ a red coat today.

- 10. 'Is it raining outside?' '____, it isn't.'
- 12. 罐
- 13. 濕的相反

		2					
1		2		3		4	
l							
					Towns of the second		
5	6						
	7						
8			9	10			
				10			
			11		12		13
						, v	
14			15				
14			15				

當你提議做某活動時,你便可以用let,例如:

- ★ Let's go swimming! (讓我們去游泳吧!)
- ★ Let's sing the song! (讓我們來唱這首歌吧!)

直3

除了騎自行車可以用ride,原來我們乘巴士或坐火車 等交通工具也可以用ride,例如:

- ★ ride in a bus (坐巴士)
- ★ ride on a train(坐火車)
- ★ ride in a car (坐汽車)

穿衣是put on,脱下衣服則是take off。

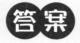

- 1. 窗的眾數
- 6. 感受到
- 7. 房屋
- 10. 名字
- 12. 米飯
- 16. 面試

易度

- 1. 願望;希望(動詞)
- 2. 大自然
- 3. 常常;經常
- 4. are waving our hands.
- 5. If I shut my eyes, I can't _____ anything.
- 8. 男人的眾數
- 9. 腦
- 11. 移動的過去式
- 13. 城市
- 14. Sam. Alex and John my friends.
- 15. 電視機的縮寫

	1		2		3	4	5	
					6			
		i						
	7							8
9					10		11	
12		13						
				14	15			
16								
			V 144					

讓我們學一些常用的祝福語吧,在節日的賀卡上寫 上祝福語,朋友或親人收到時都會感到十分溫暖。 例如:

★ Wish you a merry Christmas.

(祝你聖誕快樂。)

★ Wish you success.

(祝你成功。)

★ Wish you good luck.

(祝你好運。)

* Wish you happy birthday.

(祝你生日快樂。)

★ Wish you joy in the coming year.

(祝你來年快樂。)

如果我們想告訴別人我們做某事情的習慣,除了可以 用often,還可以用sometimes(偶然)、always(總 是)、seldom(很少)和never(從不)。例如:

★ I sometimes drink juice.

(我偶然喝果汁。)

★ I always go swimming with my friends.

(我總是和朋友們一起去游泳。)

★ I seldom eat pork.

(我很少吃豬肉。)

★ I never smoke.

(我從不抽煙。)

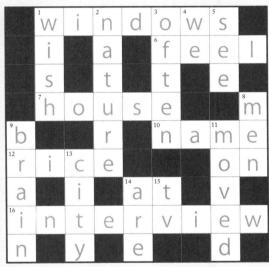

Wife: Why do you go out on the balcony when I start singing?

Done 90 Green Jone 90 Green Jone 90

Husband: Because the people would think I am beating you.

(妻:為甚麼我開始唱歌時你就會走到陽

台?

夫:因為別人會以為我在打你。)

横

1. _____ people came to the party.

(很少人參與派對。)

- 4. 小販
- 5. 細小的
- 6. 康復
- 7. 任何人
- 9. 視力;視覺
- 10. for example的縮寫
- 12. 溫和的; 溫柔的
- 13. We are Class 3A.

- 1. 朋友的眾數
- 2. 為甚麼
- 3. 因為
- 6. 熱(名詞)
- 8. 應該, You _____ to help your mother do the housework.
- 11. 誘捕動物的陷阱

	1	2	7		3	
		4				
5						
				6		
7		8				
	9				10	11
12					13	

few是形容有少量的東西,而那東西必須是可數的,例 如people(人)、hours(小時)、minutes(分鐘) 、questions(問題)等。

eg的正式寫法為e.g.。

直8

如果我們要告訴別人應該做甚麼事,我們可以用ought to 或should,例如:

★ You ought to / should listen to what your teacher says.

(你應該留心聽你老師所説的。)

★ You ought to / should keep quiet. (你應該保持安靜。)

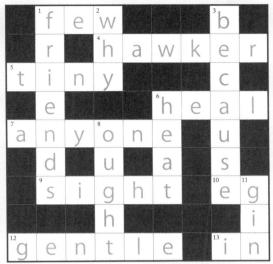

▶横

- 1. 蝴蝶
- 5. 兩個肩膀
- 7. 美國的縮寫
- 8. 蝙蝠
- 9. 求救訊號

10. good	(再見)
----------	------

- 13. 抽屜
- 15. 測驗
- 16. _____ bean (黃豆)
- 17. You can use a pencil _____ a pen to write something.

- 1. 巴士的眾數
- 2. 長褲
- 3. 清除;除去
- 4. 昨天

6. 法例

12. 'Are you a boy?' ' _____, , I am.'

14. 腐爛

1		2		3		4
5			6			
		7			8	
9					10	
	11			12		
	13				14	
15				16		
13				10		
17						
17						

橫7

美國的全名是The United States of America(美利堅合眾國),意思是由50個州合成的國家,人們一般取其主要字眼的首字母來稱呼她,即大楷字母USA。當我們用USA時,必須要說 'the USA'。

橫9

緊急求救訊號必須為大寫字母,即SOS。

橫16

用黃豆製成的食物可以用soya 開頭,例如soya sauce (豉油)和soya milk(豆漿)。可是豆腐則叫tofu或bean curd。soy則是美式英語。

直2

褲子一定有s字,且是一雙雙的,即a pair of trousers。如果想説兩條褲,便是two pairs of trousers了。

直4

凡是記述在昨天(yesterday)發生的事,都必須用過去時式(past tense)。

例如:

★ I <u>ordered</u> a cup of coffee yesterday. (我昨天點了一杯咖啡。)

以上劃了底線的動作詞語便是轉了過去時式,你知道 它的原形嗎?(答案在下面的填字格內)

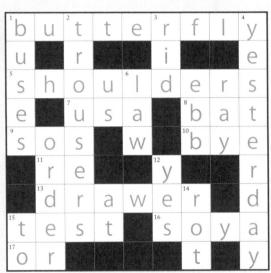

難易度
★★★★★

- 2. 缺口;間斷
- 4. 顫抖
- 5. 線條;字行
- 6. 鴨子
- 7. win的過去式
- 8. 逗留;停留
- 12. 在裏面
- 13. 正午
- 14. 露水

- 1. 時間
- 2. 地面
- 3. 袋子的眾數
- 4. 安靜的
- 8. 快速旋轉
- 9. 而且; 環
- 10. 'How old is your brother?'
 '_____ is sixteen years old.'

11. 攝氏零度或以下的水

			1			2		3
	4							
5					6			
		1 1 1 1 1 1 1 1 1 1 1 1 1 1 1 1 1 1 1		7				
8		9						
					10		11	
12								
13						14		

time作為「時間」的意思是不可數的,不能加上s;但 是作為「次數」的意思則是可數的,例如:

★ How many times have you been to Beijing? (你到過北京多少次了?)

ground是地面,那麼「在地下」該怎樣寫呢?你還 記得「在下面」該用哪個字嗎?答案便是under,在 地下便是underground了。因此在英國,地下鐵便索 性叫作the Underground了。

口袋是pocket,伸手進別人口袋偷東西的人便叫 作pickpocket(扒手),pick有挑選、採摘的意 思,pickpocket這個字是否很貼切呢?

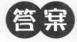

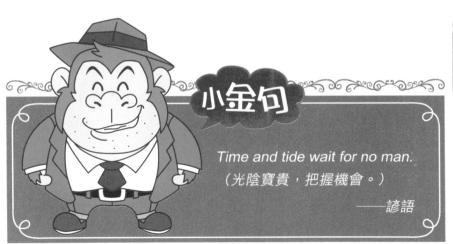

- 1. 他自己。例句:He did the work by _____
- 6. 頂部
- 7. 運用
- 8. 果仁
- 9. 踩;行走
- 12. flower _____(花盆)
- 14. 同意
- 15. sun

直

- 1. 誠實
- 2. 火柴的眾數
- 3. 擴張
- 4. 香蕉、蘋果、橙等食物的種類
- 5. 車輪的眾數
- 10. 戒指
- 11. 癢
- 12. 體育課的簡稱
- 13. Mum is going to take _____ to Disneyland. I am very happy.

挑戰篇

-	The second secon								
	1		2		3		4		5
THE PROPERTY OF THE PROPERTY O			6				7		
and the particular and the parti				1 244					
PERSONAL PROPERTY.					8				
	9	10						11	
Control of the Control						12			
				13					4
	14						15		

pot是煮食用的鍋,它可以變身成為一個擁有別的含 意的字,例如:

- ★ teapot (茶壺)
- ★ coffee pot (咖啡壺)

fruit(水果)作為一種食物種類是不能用眾數(加s) 的。例如:

★ Bananas, apples and oranges are fruit. (香蕉、蘋果和橙是水果。)

PE的全寫為Physical Education。Physical的意思是 「身體的」,Education是「教育」的意思。

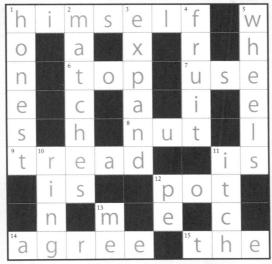

業易度
★★★★★

▶横

- 1. _____ questions; give answers
- 5. get的過去式
- 7. 全副骨骼
- 8. 換言之;也就是
- 9. 相反的
- 11. 從來沒有
- 13. 只有
- 16. 一個也沒有;毫無。例句: _____ of them have arrived. (他們一個也沒有來。)

- 2. 跳繩
- 3. _____ clear of train doors. (不要靠近車門。)
- 4. 季節
- 5. went的現在式
- 6. keep _____ doing (繼續做)
- 10. write的過去式
- 12. 選舉;投票

14. 日元

15. out的相反

1	2	3		4		5	6	
7								
	8				31			
9								
								10
				11		12		
13			14					
					15			
			16					

橫8

ie一般寫成i.e.,這個字原是由拉丁文id est演變而來,即是that is的意思。例句:

★ I like soup, i.e. meat soup, and fish. (我喜歡湯,即肉湯,和魚。)

直6

有一些動詞加了on、up、in等介詞會與原來的意思不同,好像keep原有「保存」、「保持」的意思,加了on便變成「繼續」的意思了。這類詞語叫作phrasal verb(短語動詞)。

讓我們認識一些實用的短語動詞吧:

- ★ give up (放棄)
- ★ look after (照顧)
- ★ look for (找尋)
- ★ go over (仔細檢查)
- ★ keep out (不准進入)
- ★ get up (起床;站起)

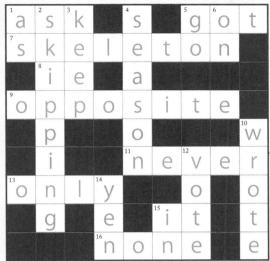

來試試以下的小測試,看你對自己的骨骼 有多少認識!

- 2. How many bones are there in a human body?
- 3. Why don't skeleton have noses?

。(骨息骨煙)

2. 206 for an adult's body.
3. Because most of the nose is not made up of bones. It is made of cartilage.

· 更骨的骨蓋賴床骨盤對重 · (骨础) 'Um97 . f

187

易度 **

橫

- 1. 睡着;熟睡
- 4. _____ the weather is fine, we will go on a picnic.
- 5. Look! The flower is beautiful!
- 6. That is my dog. _____ nose is red.
- 8. 家庭
- 12. 遙遠
- 13. 一個「剔」號
- 14. 大袋(通常用來裝麵粉、馬鈴薯等)
- 15. I want _____ go to the playground.
- 18. Tom has a bookshop. He _____books.
- 19. 千克的縮寫

- 2. 沙發
- 3. 飛機師
- 7. 打字員
- 9. 文章
- 10. Don't do that. _____ is dangerous!
- 11. 烘麵包或糕餅等

12. 肉

16. 橡樹

17. isn't =

1	2			3		4	
5				6	7		
	8	9	10				11
12							
				13			
14					15	16	
				17			
	18					19	

- 一大袋東西便是a sack of something,例如:
 - ★ a sack of soya beans (一大袋黃豆)
 - ★ a sack of rice (一大袋米)

我們想做一件事是 I want to do..., want後面的動詞 必須要有to。

橫19

千克的「原形」是kilogram。

flesh通常是指肌肉,不是我們吃的牛肉(beef)或豬 肉 (pork)。

我們常在對話中用到縮寫,例如:

- ★ 'Look! It's excellent!'
 - (看!那真棒!) 【It's = It is】
- * 'She's clever.'

(她很聰明。) 【She's = She is】

直17

★ 'I'd like to have a glass of juice.'

(我想要一杯果汁。) 【I'd = I would】

* 'I'll be late.'

(我會遲到。)【I'||=| will】

這是配合説話速度的緣故。

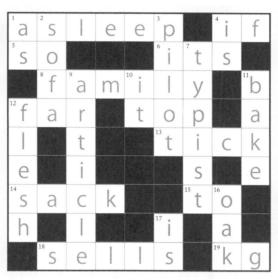

A child sees everything, looks straight at it,

examines it, without any preconceived idea...

(孩子看見所有事情,直視這些事情:審查它們,沒有先入為主的念頭……)

─Olive Schreiner(南非作家)

- 1. 嗜好
- 4. 但是
- 6. _____room (試身室)
- 9. 屋頂
- 10. 月亮出來的時候
- 12. 牛肉
- 14. 女子名,Elizabeth的暱稱
- 15. 繩子
- 17. cycling
- 18. _____ smoking. (不准吸煙)

M

- 1. 可怕的
- 2. 之前
- 3. 'Have you finished the homework ____?' 'Yes. I have.'
- 5. 緊的
- 7. _____ you don't work hard, you won't pass the examination.

- 直
- 8. 孿生
- 11. 河馬的縮寫
- 13. 旗
- 16. _____ Sunday morning

1	2		3		4		-
1	2		3		4		5
		7		8			
	6	/		8			
9			700		1112		
			10				
			10			11	
12		13					
			45, 3				
14				15	16		
							9
		17			18		

直2

Before和in front of不能交換用, in front of 是指某東西的位置在另一種東西前面;而before則是指某事情發生在某事情之前,例如:

★ John went out before it rained.

(約翰在下雨前出去了。)

★ There is a pen in front of the box.

(有一枝筆在盒子前。)

直3

如果我們想問別人是否已做了某事情,我們可以在問題中加上yet,例如:

- ★ Is Mum home yet? (媽媽回家了沒有?)
- ★ Has she bought the doll yet? (她買了洋娃娃沒有?)

直11

河馬的全寫是hippopotamus。

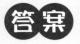

They don't have thumbs to ring the bell. (為甚麼大象不會騎單車?

(為甚麼大象不會騎單車? 牠們沒有拇指按鈴。)

- 1. 蚊子
- 4. 雨傘的眾數
- 7. 舊的相反
- 8. 任何地方
- 11. 「花名」的眾數

- 1. 高山
- 2. 隧道
- 3. 島

- 5. The pen is mine. Give it back to _____
- 6. 遲到
- 9. 煮東西的鑊
- 10. 'Have you _____ tried coffee?' 'Yes, I have.'
- 12. We usually go swimming _____ summer.
- 13. I _____ afraid of staying at home alone.

1		2					
							3
4	5			6			
7							
					1		
8			9			10	
11	12			13			
			1				

isle通常用於英語詩歌中,英國著名諾貝爾得獎詩人 William Butler Yeats (葉慈) 便曾創作著名的詩歌 The Lake Isle of Innisfree,訴說自己嚮往到一個寧靜的小 島Innisfree生活,尋求心靈上的平安。

如果我們要問人曾經做過甚麼事,ever可以派上用 場,例如:

- ★ Have you ever been to Japan? (你有沒有到過日本?)
- ★ Have you ever travelled by plane? (你有沒有試過乘搭飛機?)

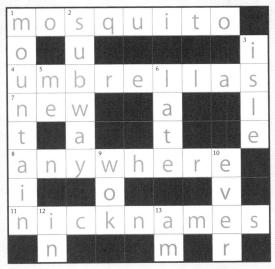

and on the fare on the fare

來試試以下的小測試,看你對蚊子的認識有多少。

- 1.Male mosquitoes do not suck blood. (True / False)
- 2.Mosquitoes have two pairs of wings. (True / False)
- Mosquitoes can be found near ponds. (True / False)

3.True

2. False (They have one pair of wings.)

1. True (Only female mosquitoes need the protein in the blood to produce eggs.)

- 1. 鄰居
- 7. 更好的
- 8. 出席(聚會、儀式等)
- 11. 注意;留心。 例句:Pay _____!
- 13. 旋渦
- 14. '_____ old are you?' 'I'm twelve years old.'

直

- 2. 選舉
- 3. I have _____ your e-mail.
- 4. I am _____. (我感到沉悶。)
- 5. 直至
- 6. 烤
- 8. 醒着。例句:He has not slept. He is _____. (他沒有睡。他醒着)
- 9. 每一個
- 10. I live _____ my parents. (我和父母同住。)
- 12. 現在

1	2	3	4		5	6
7						
8		9				
				10		
11						12
13				14		

比別人或別的東西優勝時可用better, 例如:

- ★ My examination results are better than Mary's. (我的考試成績比瑪麗好。)
- ★ He draws better than his brothers. (他比他的兄弟畫得出色。)

「最好 | / 「最佳 | 則是the best , 例如 :

★ Jenny is the best swimmer in our school. (珍妮是我校最出色的泳手。)

直3

當你收到朋友的電郵時,你可以用 'Got it, Thanks.' 來回覆別人,意思是告訴別人你收到郵件了。

如果某電影或書本很沉悶,我們可以説它們boring, 例如:

★ I don't like this film. It is boring. (我不喜歡這齣電影,它很沉悶。)

準

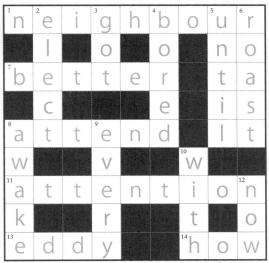

難 易 度

★ ★ ★ ★

▶横

- 1. 野餐
- 5. _____ is a beautiful baby.
- 7. 點頭
- 8. To keep a dog needs much money, ____ .___ . ___ . ___ . ___ . ___ .
- 9. There are thirty people _____ in the hall. (在禮堂內有30人坐着)
- 11. 蟾蜍
- 12. 修女
- 14. 通常
- 16. 用來做汽水的材料
- 17. Earth

直

- 1. 囚犯的眾數
- 2. 繼續的過去式
- 3. There are seven days _____ a week.
- 4. 數東西(動詞)
- 6. He goes to the market on _____. (他逢星期二都會到市場去。)

10. 目標

13. _____ of order(壞了)

15. 說謊

1		2	3	4		5	6
			7				
			,				
					161.5	8	
			4.7				
9					10		
				11			
				11			
12			13				
		14				15	
				1			
1/				17			
16				1/			
	1				A LANGE BOOK OF A	and the case had been been been been	

橫9

這句句子是運用了進行式(continuous tense),在其他情況中,你也可以運用進行式,例如:

- ★ Look! The train is coming.
 - (看!火車來了!)
- ** 這是現在進行式(present continuous tense), 事情在説話的時候發生。
- ★ I was doing homework when Mum came home.

(媽媽回來時我正在做家課。)

** 這是過去進行式(past continuous tense),事情在過去了的某一特定時刻發生,例如在媽媽回來的時候這一特定時刻。

宇		現在和過去進行式的形式是	
	•	况任"他四五姓"门八的形式定	٠

am / is / are +	ing; was/were +	inc
-----------------	-----------------	-----

直13

電梯、電話、時鐘等機器或裝置壞了都可以用out of order。例如:

★ The lift is out of order.

(升降機壞了。)

p	i	² C	n	3	⁴ C		5	⁶ t
r		0		'n	0	d		u
i		n			u		8	е
⁹ S	i	t	t	i	n	¹⁰ g		S
0					¹¹ t	0	а	d
¹²	u	n		13 O		а		а
е		14 U	S	u	а		15	У
r		е		t			i	S
¹⁶ S	0	d	а		¹⁷ t	h	е	

小笑話

Why don't cows have any money? Because farmers milk them dry.

(為甚麼牛沒有錢? 因為農夫將牠們榨乾了。)

- 1. 第四
- 4. 鞠躬
- 5. 木琴

- 13. I _____ playing with my cat when the telephone rang.
- 14. 吃東西的過去式
- 15. 頑皮的

直

- 1. 狐狸
- 2. 小費
- 3. 甜筒雪糕的筒
- 6. 乳酪
- 7. a box _____ matches (一盒火柴)
- 8. 打招呼時說的
- 9. 平底鍋
- 10. 高升;高飛

11. I have _____ to Shanghai.

(我曾經去過上海。)

12. 想要;想做某事

1				2			3	**
						4		
5	6		7		8			
	-			9				
10		11					12	
						13		
14						4 5		
		15						

橫第7行第1格

ore是礦石或礦砂。

直7

有一些東西(尤其是不可數的東西)是不能直接用a、an和the的,例如:

- ★ a piece of wood
- ★ a piece of paper
- ★ a piece of chalk
- ★ a piece of glass
- ★ a bottle of milk
- ★ a cup of coffee

a piece of 包含「一塊」、「一截」或「一段」的意思。飲品如牛奶(milk)和咖啡(coffee)則須説明裝載它的容器。

直第7行第2格

bo是boo的縮寫,當我們想表示不同意或鄙視時便可 以發出這個聲音。

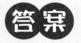

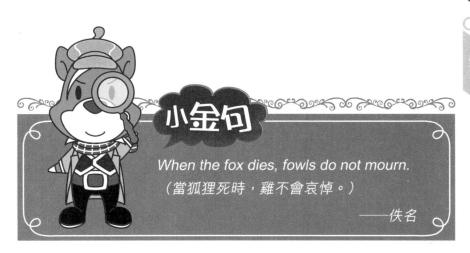

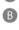

索引	INDEX	
	Α	

above ·····	62, 93
absent	51
ace ·····	117
acid	59
across add	128
add	43, 100
adjectiveadult's	10, 147
adult's	187
advise, advised	134, 135
aero······	15
aerobatics ·····	14
aeronautics	14
again ·····	63 , 104
age ······	159
ago ······	11, 73
agree ······	183
aid ·····	39
air ·····	63, 76
all····	. 31, 38, 51
all-in-one	150
alone	151
along ······	101
also ······always	121, 179
always	63, 166
amend ·····	67
an 27, 67,	81, 113, 159
and ·····	47, 105
angel ·····	11
angry ·····	39, 97
animals	121
Ann ······	31
answered	42
any ·····	97, 191
anyone	171
anything ·····	159
anywhere	199
appeared	73
apples	182
April ·····	85
area	47
argues ······	117
around	···· 113, 142
arrived	63
art ·····	. 30, 31, 129

article ·····	191
arts ·····	. 30
as ······	. 89
ash	. 77
ask, asks, asked · · · 42, 135, 142, 159,	187
asleep	191
astronaut	159
at ······ 47, 62, 63, 85, 93,	121
ATMs	163
attack ·····	109
attend ·····	203
	203
Australia	62
awake	203
	· 47
В	
back ·····	104
bad ······	. 55
badminton	81
bag ·····	139
bake ·····	191
balconyball	167
ball ·····	63
ban ·····banana, bananas ······ 63 ·	151
banana, bananas ····· 63 ,	182
bar ······	43
bare	63
bark, barks43	, 63
bat ······73,	175
be, is, are, am, was, were, been	11,
15, 19, 23, 43, 46, 47, 55, 58, 62, 63,	77.
97, 109, 113, 121, 125, 135, 139, 143, 1	51.
167, 179, 191, 199, 211	- ,
167, 179, 191, 199, 211 bean curd	174
hear	47
	167
	146
	183
hecome	19
become ······	19
bed	19 50
become bed 190.	19 50 195
become bed beef 190,	19 50 195 195
become bed beef 190, before	19 50 195 195 92
become bed	19 50 195 195 92 143
become bed	19 50 195 195 92 143 178
become bed beef 190, before beginning behind 62, Beijing	19 50 195 195 92 143 178
become bed	19 50 195 195 92 143 178 195

Dellei	202, 203
between	93
bib ·····	125
bikes ·····	195
bin	73
bird	93
birthday ·····	166
biscuits	129
bite ·····	143
blood ·····	199
blue····	11
board ·····	121
boat·····	73, 128
body 55	, 151, 187
bone bones	187
boo(bo)	210
book ······	100, 108
boom ·····	30
boot·····	55
bored, boring	, 202, 203
both	
bottle ·····	163, 210
bow ·····	211
box, boxes······	124, 194
boy ······	43
brain, brains ······	121, 167
breaks	47
bring	117
brothers ······	202
bubble	101
bubble bowl ·····	101
hubblehead	101
bumped	63
hun	43
bus. buses 62	, 162, 175
bus, buses 62	67, 195
hutterfly	175
buttons	50
buttons	55, 194
by 55, 59, 62, 85	. 125, 159
bye	175
C	
cab ·····	121
ooko	80
ooko	80
cab cake an, could and a4, cannot, could not	80

can't 207
cap
cartilage · · · · 187
cat, cats
chair 92
chalk 210
chase 113
chemicals
chew
chicken ······ 73
child, children85, 191
child, children85, 191 China46,47,73
chirp 30
Christmas
cinema
city
classmate
classroom 92 cleaned 42
cleaned ······ 42
cleaner 155
clever
cliff ······ 105
clocks ······ 19
closed
closer 171
clouds······81
clown 81
club······ 84
co
coat
co-author
cock
coexist72
ooffoo
coffee pot
coins
Cold 100
come, came, coming
coo
cope 143 copied 47
cows
crashed 42

East 51,	, 77
Easter ·····	
eat, ate, eats ··· 38, 39, 46, 47, 73, 81, 108, 159, 167, 211	
108, 159, 167, 211 eddy	วกร
edges ·····	. 25
education ·····	33 199
effort	102
egg, eggs ······ 43, 81, 100, 129,	100
eight	199
elect	202
elephant, elephants	203 105
eleven	190
elf ·····	02
Elsa	105
e-mail · · · · · · · · · · · · · · · · · · ·	
end, ends 51,	
English	, 9Z 35
enough ·····	, 33 100
err ······15,	109 175
err 15,	175 175
error escape	173
Eva ·····	. 05
eve81,	105
eve	120
even number·····	21
even number	. Z0
ever 97, 125, every 27, 2	199
every day	203
every night·····	26
every Saturday	26
every Saturday	. 20
everyday	. 20
everyone everyone	26
everything26,	101
everywhere	191
exam	26
exam examination	. 80
examines	202
examines excellent	191
excellent	190
exercise ·····	
exit expand	
expand	183
- , -	121
F fair	
fair ·····	14
fall sick ·····	142
false	199

ramily	191
far ·····	23, 191
farmers ······	27, 207
fast ······	109, 124, 125
faster ·····	124
fat ·····	10, 51
father ·····	22, 85
feel feeling	100 120 167
famala	199
femur ·····	187
ferry·····	85
few	14, 15, 171
film	18
fin	147
find found ·····	108, 199
finishes finished	42, 135
fire fires ·····	154, 155
fireman ······	22, 154
first ·····	96 100
first old kit	72
first-class ······	150
fich fichee	38 39 124
fisherman ······	
fishing kit ······	72
fit, fitting ·····	14, 147, 195
flag ······	195
flesh ······	190, 191
flour·····	190, 191
flowers	183
fluent	103
flute	154
fly, flying, flies	10.02.142
fly, flying, flies food	19, 93, 143
foodfootstep	109
footstepfootstep	97
fourthfowls	211
	211
fox ······	211
french ······	109
friend, friends26	6, 27, 166, 171
friendship	171
front	104
fruit ·····	182, 183
fry	89, 105
fun ·····	155
G	
game ·····	121
0	07 170

gentle ·····	171
get up ······	186
ghost ······	125
giggle ·····	101
gin ······	171
ginger	93
gingerbread	93
girl	63
give up	186
glass	147, 191, 210
glory ······	175
go, goes, went ····· 1	1, 14, 39, 50, 55, 62,
81, 93, 104, 187, 195	
go over	186
goal·····	207
goat·····	97
good ······	43, 138
good luck ······	166
good morning	96
goodnight	138
gorilla ······	31
got ······	97, 104, 187, 203
got it ·····	202
grass ······	139
ground ·····	178, 179
guess, guessed ······	42, 59
guest ······	
guitar ······	154, 155
gum·····	
gun ·····	89
guy ·····	
E	
ha	24 151
hair ······	31, 151
hamburgers	
ham······	
nam·····	40 404
happen, happened happy	
happy have, has, had	24 24 442 447 179
hatch ······	113
hawker ·····	171
hay ······	
nay ·····	18, 23, 80, 129, 179
he ······head ····································	10, 23, 00, 123, 173
headmistresses	
heal·····	171
hear, hearing	47 139
heart	67
HUGHL	01

Identity Card · · · · · 150

if	113 ·· 85 117 194 112 139 ·· 89 ·· 81 179 146 167
into	159
island 34 isle 198,	1, //
it	1/17
159, 191, 207 item	117
its11.	191
itself	51
IVE	85
ivy ·····	147
jacket ·····	12/
January ······	85
Japan ······	198
jar	147
iet ·····	143
joins ·····	85
joy ·····	166
juice166,	191
jumbo ·····	143
jumping ······just	129
	. 59
K keep19, 55,	107
keep out ······54,	· 54
keep quiet ······47,	170
keep it secret	. 54
kea	109
key ·····	125
key person·····	124
key point	124
kg, kilogram ····· 88, 190,	191

	8.	N		8	
۹			ø	۳	
		_			
á	g	8		À	

	-	900	L	
á	п		ъ	ĸ.
s	ŀί	₹/	:5	8

	o		R	Ĺ
ŝ	8:	W	и	
	ų		у	F
		_		
٨				

kilometer73	
kin 171	
king 142	
kit	
kitchen 89	
know 35, 67, 158	
L	
LA 62, 63	
ladder	
lap	
large 146	
largest	
last 62	
late 63, 104, 108, 191, 199	
laughed 42	
law 175	
leaf, leaves	
learner 124	
LEGO 23	
let	
letter	
library 92, 93, 163	
lie 207	
lift	
1111	
9.1.	
listen, listening, listened ······· 42, 46, 170 lit ····· 143	
live 34, 92, 108	
log11	
lollipop ····· 55	
London	
long 59	
look ····· 62, 190, 206	
look after	
look for	
Los Angeless(LA)····· 62	
lot 80, 150, 151	
loudly 47	
love 35, 85	
M	à
M)
ma 151	

kid ··

63	machines		163
73	magic tricks ······		146
171	made ······		
142	male ·····		199
73	man, men ······22		
89	many ·····		146
35, 67, 158	market ·····		80
	martial arts······		146
	mashed ·····		143
62, 63	matches ······		183
147	May·····		117
63	me 18, 22,	129, 183	, 199
146	meat ·····		73
187	melody		121
62	melt ·····		142
, 108, 191, 199	mends		135
42	mermaid·····		135
175	merry		166
104, 105	mid		117
124	Mid-Autumn ·····		150
23	Mid-Autumn Festival	92	1, 116
163	midday ·····		116
138	mid-June		116
92, 93, 163	mid-May ·····		116
207	midnight ·····		116
206	miles		105
97	milk ·····	147, 207	, 210
11, 18, 38, 108	milkshake		
47, 179	mini ·····	113	
93	minibus		112
19, 183	minicake·····		112
42, 46, 170	minicomputer		112
143	minidictionary		112
14	miniskirt ·····		112
34, 92, 108	minutes	80), 170
11	meow ·····		30
55	miracle, miracles		139
151	Miss ·····		116
59	miss ·····	116	5, 117
62, 190, 206	mittens		139
186	mix		100
186	moment ·····		151
62	Monday ····		62
80, 150, 151	money·····	150, 163	3, 207
47	monsters		113
35, 85	moon ·····		76
	morning ·····		97
	mosquito, mosquitoes		199
151	most ·····	38, 6	57, 85

number (no.) ·····	72
nun ·····	207
nut ·····	85, 183
0	
C. C	
oak ·····	191
obeys ·····	101
o'clock ·····	62, 92
octagon ·····	
octave·····	
October ·····	
octopus, octopuses ······	88, 124, 125
odd ·····	31
of 23, 62, 73,	
011	97, 105, 129
01011	81, 166, 167
	39, 100, 125
	88, 89, 125
3	
0.00	1.10
on ····· 63, 105, 143, 151, 1	
onlyonto	
	67
operateopposite	187
or 23,	77, 121, 175
orange, oranges	
orbs	11, 146, 182
ordered ·····	
ore	110
ostrich·····	
ought ·····	
our ·····	
out 1	104 206 207
out of order	206
outside	92, 143
over·····	101, 104
overcoat ······	134
overslept ······	15
owl ······	
own ·····	
OX	30
ovster ·····	151
5,5.5.	101
P	
p.m	66, 67
pa	85

 rectify 175

red 11

seagull 58

seahorse 58 seal lion 58 seasick 58 seaside 58 season 187 seat 117 seaweed 58 second 51, 96 see, seeing, saw 11, 23, 27, 35, 81,
97, 139, 167
seed
100
101
send
sh
shake 55
shark's
she
shines 129
shirts ····· 77
shop
short
should 170
shoulders 175
shouted 42, 47
shower
shrimp
shut
si
sick
sight 171
similar ····· 113
sin
sing, singing 162, 167
sip
sir
sister
sit, sitting, sat
skeleton, skeletons
skipping
sleep, sleeping
small 146 smiled 42
smoke
so
so much 34
54

3000	201
sofa······	191
soil ······	143
solo ·····	105
some ·····	38, 100, 146
something	190
sometimes ······	166
son ·····	35. 93
sona	162
sorry	47
SOS·····	174, 175
soup	19, 46, 147
south	100
sow	113
sova	174 175 190
sava haans	
	171
	171
soya sauce soy speak, speaks speed	174
sneak sneaks	34 47
speak, speaks	73
speed	80 81
spend, spends, spent ······ spin ·····	
spin ······spin ······spin ······spin ······spin ······spin ······spin ·······spin ······spin ······spin ······spin ······spin ······spin ······spin ······spin ······spin ·······spin ········spin ······spin ·····spin ····spin ·····spin ····spin ····spin ····spin ····spin ·····	179
spoon ·····	46
sport, sports ·····squeaked ·····	22, 51
squeaked	47
stamps	6/
star, stars	76, 80
start, starts, started	43, 81, 167
stay ·····	179
start, starts, started stay step, stepping sticks stools	120, 121
sticks	171
stools	39
ston	113
straight	191
stranger ·····	109
streets·····	23
student students	15 63 80 150
studving	80
subway ······	199, 211
SUCCESS	125, 166
such	59
elick	199
elim	22 67 113
sum ······sun	51 76
sunlight	77
super	20 21
supersuperman	20
superman	00

supermarket ·····	80
supernatural ······	80
superstar ······	80
support	67
sure	50
surname ·····	135
surrounded	113
survive	113
summer ·····	202
swimming 81,	135, 162, 166
summer swimming 81,	97
_	
T table	
table	93
tag	147
tail ·····	66
take·····	34, 159
take off	162
tall	10
tap ······	43
tape·····	147
tar ·····	89, 151
tacta tactas	130 130
taughttaxi	117
taxi ·····	147
te	34
tea	34, 125, 159
teacher	15, 47, 89
teaching kit	72
teapot ······	182
tear tears	47 112 113
teddy	155
tedious	51
· · · · · · · · · · · · · · · · · · ·	4 4 7
tel	84. 85
teenager tel tell, tells, told ten test	47, 59, 84, 97
ten ······	67, 92
test ·····	175
than·····	202
O. I	000
that	43 100
the 3/1 77	139 183 207
the New Territories (N.T.)	27
thanks that the 34, 77, the New Territories (N.T.) the Underaround the United Kingdom	17Ω
the United Kingdom	
the United States of America	66 174
their their	31 35 95
them	10 72
then	07 100
men	97, 100

they	18
thick 1	43
think, thought31, 1	67
thirty	80
through ·····	31
thumbs ····· 1	95
Thursday	96
tick ····· 1	91
ticket93, 1	04
tick-tock ·····	30
tide ····· 1	79
tie ······ 1	55
tight····· 1	95
time, times 80, 108, 163, 178, 1	79
tin 1	63
Tina ·····	72
tiny ····· 1	71
tip 2	211
	43
to ····· 19, 62, 63, 73, 81, 85, 129, 134, 1	91
	207
toe, toes	43
tofu ····· 1	74
tomorrow ·····	81
ton 1	17
too 10, 27, 97, 1	21
top 1	83
toss ·····	35
toward ·····	23
town ·····	77
train 162, 2	06
trap ·····	
travel, travelled · · · · · 142, 1	98
tray ·····	97
tread 1	83
tree ·····	93
trips·····	31
trophy · · · · 1	05
trousers	
true ····· 1	99
true friend 1	71
try 34,	97
	63
Tuesdays 2	07
	83
turn, turns, turned 67, 100, 1	04
TV 1	67
twenty47, 1	59
twin 1	95

two	
typist ·····	
Tyrannosaurus	7:
	J
ugly ·····	14
umbrellas ·····	19
un	5
under ·····	62, 73, 93, 17
underground ·····	178
undo, undid ······	51
undress, undressed	50
unfair ······	
unfit · · · · · · · · · · · · · · · · · · ·	
unhappy·····	1;
unit ·····	
unsure	
until	203
unusual ·····	89, 120, 16
up	19, 38, 39, 125, 15
USA·····	
use ·····	15 8/ 18
usual ······	10, 04, 10
usually	
	I
van ······very	
van ·······very village ····································	
van ······very ······village ······visitors	10:
van ·······very village ·····vocational ······	100
van ·······very ······village ······vocational ·····voice	100 41 11 100 100 100 100 100 100 100 10
van ·······very village ·····vocational ······	100 41 11 100 100 100 100 100 100 100 10
van ····································	10:
van ····································	109
van ····································	V 109
van ····································	109
van very village visitors vocational voice vote V waist wait waiter walk, walked	V 109
van very village visitors vocational voice vote V waist wait waiter walk, walked wall	V 109
van very village visitors vocational voice vote V waist wait waiter walk, walked wall want	V 109
van very village visitors vocational voice vote V waist wait waiter walk, walked wall want war	V 109
van very village visitors vocational voice vote V waist wait waiter walk, walked wall war warm	V 109
van very village visitors vocational voice vote V waist wait waiter walk, walked wall warm washed	V 109
van very village visitors vocational voice vote V waist wait waiter walk, walked wall warn warm washed watch	V 109
van very village visitors vocational voice vote V waist wait waiter walk, walked wall war warm warm watch water	V 109
van very village visitors vocational voice vote V waist wait waiter walk, walked wall warn warm washed watch	V 109

yummy

-6	Х	8
4	6	y
	-000	
á	V	à
- 6	83	

4	
1	
	7

web	19, 21
wed	35
weekends	92
weight	88
West ·····	77
wet ······	19, 151
what	
wheels	
when ·····	109
where ······	108
while	47
whole ·····	15
whose	158
why ······	35, 108, 171
wide ·····	
wife ·····	
will, would ·····	35, 51, 191
wind ·····	76
wings ·····	199
winner·····	96
win, wins, won ·····	35, 109, 179
wish······	166, 167
with ·····	26, 203
without	191
wok ······	199
wood, woods	105, 210
woof ·····	
work ·····	
world ·····	
World Trade Organization	n (WTO) ······ 66
writing, wrote	47, 187
X	
xylophone ·····	211
Y	
yard·····	155
vawn	121
vear	51, 117, 125, 166
vellow ······	15
ven	187
Ves	43, 175
vesterday	128, 175
vot	195
vogurt	211
volk	27
you ······	35, 38, 178
voring	

..... 15, 31, 39, 105

your...

策劃/厲河

編著 / 天海 志

封面及內文設計/葉承志 插圖/葉承志 編輯 / 陳秉坤、蘇慧怡、郭天寶、黃淑儀

出版

雁識教育有限公司

香港柴灣祥利街9號祥利工業大廈9樓A室

承印

天虹印刷有限公司 香港九龍新蒲崗大有街26-28號3-4樓

發行

同德書報有限公司

九龍官塘大業街34號楊耀松 (第五) 工業大廈地下

第一次印刷發行

2020年12月 翻印必究

© 2020 C. Tin Hoi, Multimedia Services Limited, All rights reserved. 未經本公司授權,不得作任何形式的公開借閱。

本刊物受國際公約及香港法律保護。嚴禁未得出版人及原作者書面同意前以任何形式或途徑(包括利 用電子、機械、影印、錄音等方式)對本刊物文字(包括中文或其他語文)或插圖等作全部或部分抄襲、 複製或播送,或將此刊物儲存於任何檢索庫存系統內。

又本刊物出售條件為購買者不得將本刊租賃,亦不得將原書部分分割出售。

This publication is protected by international conventions and local law. Adaptation, reproduction or transmission of text (in Chinese or other languages) or illustrations, in whole or part, in any form or by any means, electronic, mechanical, photocopying, recording or otherwise, or storage in any retrieval system of any nature without prior written permission of the publishers and author(s) is prohibited.

This publication is sold subject to the condition that it shall not be hired, rented, or otherwise let out by the purchaser, nor may it be resold except in its original form.

ISBN:978-988-74720-7-0 香港定價 HK\$78 台灣定價 NT\$350

若發現本書缺頁或破損, 請致電25158787與本社聯絡。

子 大偵探福爾摩斯

想看《大偵探福爾摩斯》的

最新消息或發表你的意見, 請登入以下facebook專頁網址。

www.facebook.com/great.holmes

網上選購方便快捷 購滿\$100郵費全免 詳情請登網址 www.rightman.net